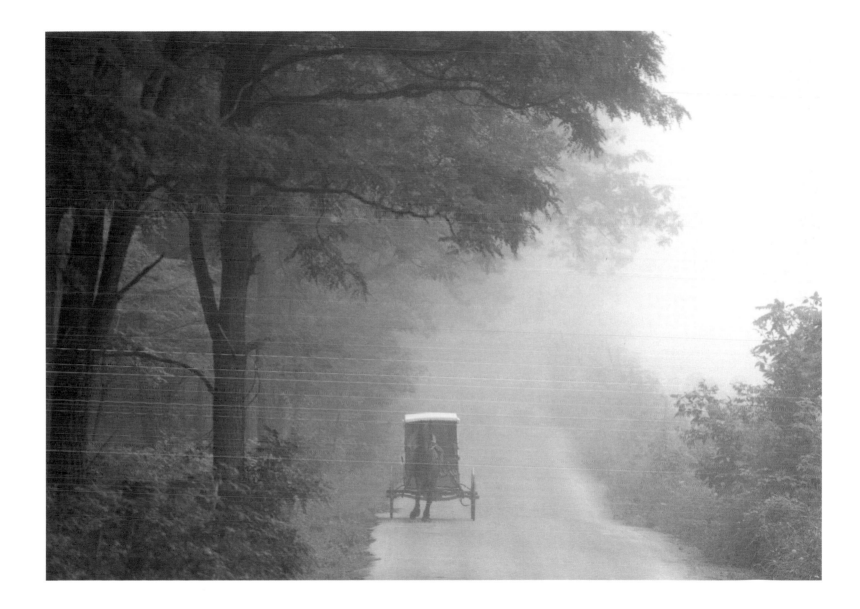

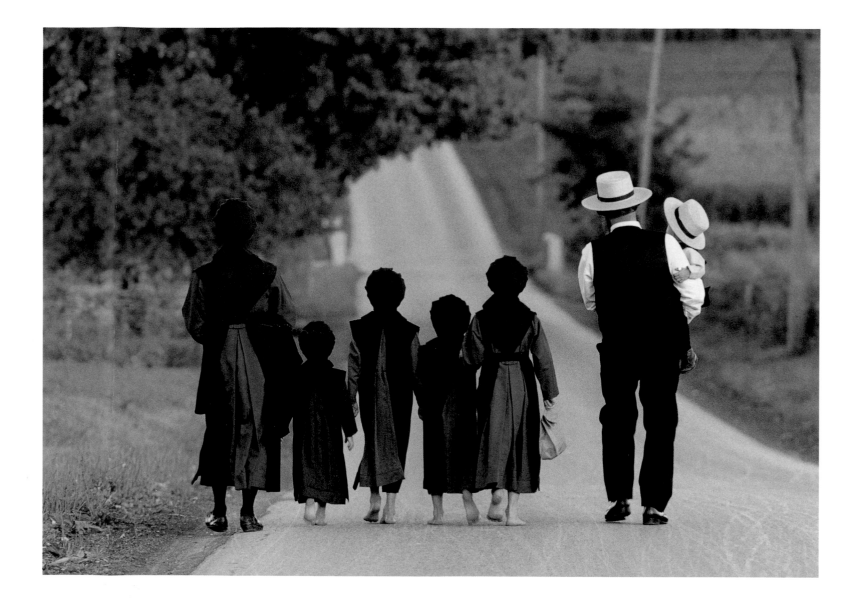

THE GIFT TO BE SIMPLE

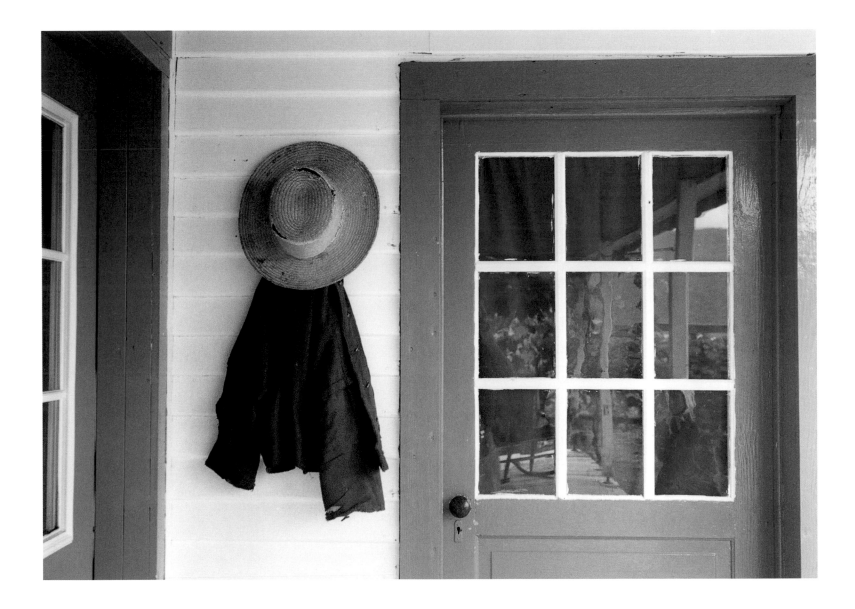

THE GIFT TO BE SIMPLE
LIFE IN AMISH COUNTRY

By Bill Coleman

CHRONICLE BOOKS
SAN FRANCISCO

Library of Congress Cataloging-in-Publication Data available.

ISBN 0-8118-3118-3

Printed in Hong Kong
Designed by Toki Design (San Francisco)
Typeset in Bembo and Trajan

Distributed in Canada by Raincoast Books
9050 Shaughnessy Street
Vancouver, British Columbia V6P 6E5

10 9 8 7 6 5 4 3 2 1

Chronicle Books LLC
85 Second Street
San Francisco, California 94105

www.chroniclebooks.com

There is no doubt that this twenty-five-year odyssey would not have been possible without the help and, even more so, the inspiration of those who aided my needs and suffered my whims: the late Bill Kinser, as well as Carl Inglesby, Urszula Kulakowski, Cookie Jones, Beate Tuchette, Dawn Kitka, Bill Timmerman, Cynthia Shultz, Gene and Barry Massin, Vicki Simmons, Tarin Chaplin, and my son, Noah.

To many nameless Amish families who quietly—as is their fashion— tolerated the many incursions, my unceasing appreciation.

A profound thanks to Dr. Holmes Morton and his staff at the Clinic for Special Children in Strassburg, Pennsylvania, who continuously give of themselves to help cure a devastating genetic illness that is usually unique among the Amish.

Lastly, thanks to fate, to the gods, or whatever led me to this neverending and wondrous path.

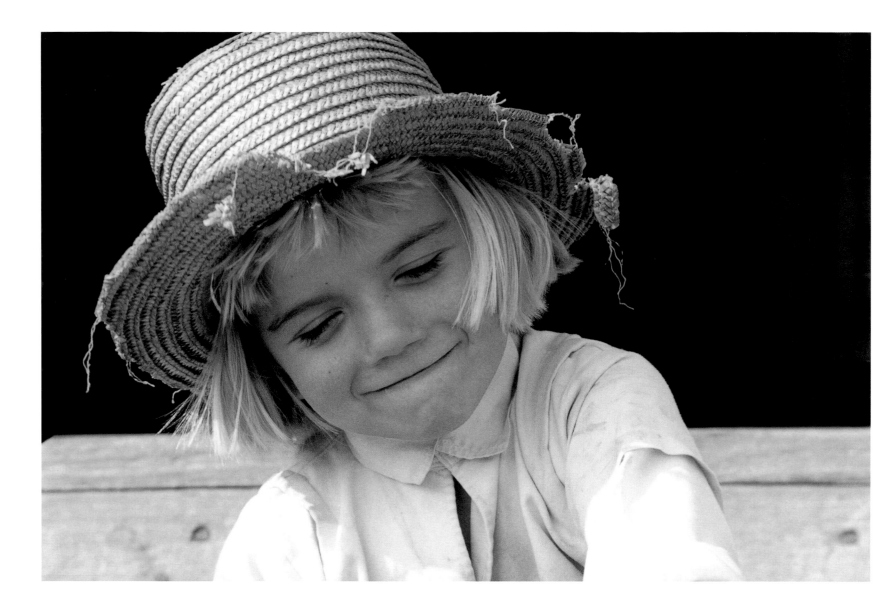

INTRODUCTION

Bill Coleman

IN LIFE, CHANGES CAN BE SUBTLE; ONLY IN RETROSPECT do you realize that you have followed a path at least ninety degrees divergent from your original direction—without having been conscious of the change.

I was fifty years old, a moderately successful portrait photographer when my life took a sizeable change in direction. I was driving along a road one day, wondering if I'd ever get a chance to pass that buggy in front of me, when I noticed that its rear-left wheel was about to fall off. I honked, the old Amishman pulled over, and together we managed to get the wheel properly seated. We spoke for a while and as we parted he thanked me for letting his people farm "our" land and encouraged me to visit some time—a rare invitation.

I visited him and his wife three or four times, always bringing a bucket of ice cream. As I drove past Amish farms, I would take a few snaps here and there, never dreaming that I would be hooked for life and spend at least twenty-five years attempting to photograph this tiny valley, trying to record a gem that few tourists ever found (though some may know of it; to this day I tend to keep its location to myself).

For at least the first few years, I was so caught up by the oneness of the people and their surroundings, that I failed to realize the depth of their reluctance to be photographed. To make amends of sorts, I stopped photographing adults, except from a goodly distance such as at an auction, and instead concentrated on the sheer beauty of the valley as it changed from season to season—and the children.

After quite a while, and to my amazement, I found that my presence was tolerated by a few of these Old Order Amish. Word got around and I was tolerated by a few more families—which still surprises me, considering how reserved this community can be. When I say "tolerated," I mean that I was permitted to take occasional photographs of the barns, buggies, and animals—and once in a while a candid of the

kids. After a while, I was allowed a bit more freedom with the camera.

Later, I became aware that there were several different sects of Old Order Amish and while their basic tenets were similar, there was a tangible lifestyle difference between them. I found myself spending more time among the so-called "Nebraska" Amish who were perhaps more "old fashioned" and more difficult to know than the others. No small factor was that their buggies had white canvas tops rather than black and therefore were more photogenic. Beyond that I don't really know why I was so unduly attracted to this group, who were known to give photographers a difficult time—but I suspect fate plays a hand when least expected.

After several years, I was seriously worried about running out of things to photograph. After all, the valley was barely nine miles long. Then I remembered back to the sixties, when war photographer Robert Capa was killed in Vietnam. I'd sent a long, impassioned letter to his photo agency in France offering to take his place at my own expense. A short while later the brief response came: "Robert Capa could come up with a masterpiece from something as ordinary as a Kansas cornfield. See what you can do in your own backyard." Needless to say, I didn't go overseas; besides I'd had enough war some years earlier. But the memory of this brief note from years back inspired me to continue looking, to keep asking, and to keep working. There hasn't been a dull day since.

Each day has been a revelation, often starting with the muted sounds of barefoot children on their way to school in the early morning fog. We can learn much from these people. Their tiny one-room schools, often with a teenage teacher, produce kids who, while never having learned of Beethoven or Shakespeare, can converse in two languages by the time they are twelve. Well-versed in the skills essential to the success of a family-run farm, they carry on a spiritual tradition that supports a life of simplicity, distanced from consumerist society.

And there is this one very small Amish graveyard, with its rough-hewn stones barely a foot tall and often with misspelled names. Cover that cemetery with a foot of snow and you'd be hard pressed to guess just what those undulating waves of snow are. I often spend two to three hours a month in this utterly silent but beautiful resting place. As careful as I try to be, I still feel like a transgressor of sorts. Once in a while a buggy comes by, and I brace myself for the expected shout to get out of their cemetery. In twenty-five years of being an interloper in this pristine acre, not once have I been asked to leave. I can only assume that the Amish are incredibly tolerant, for there is no way for them to know how carefully I've tread.

As the seasons changed, I made countless images of this one tiny cemetery with its layers of history still intact.

I have my critics—there is no shortage of them. I do enjoy a banter or two with those of serious convictions and a logical point of view. For the record, a goodly share of the profits from this book will help ease medical bills for some Amish children. I hope my critics will see these images as a love affair, albeit one-sided, between the Amish and this photographer.

But to be a photographer and to reveal to the world something very special, very fragile, very rare and whose time might be quite limited—one cannot be a casual observer of the passing scene but a predator of sorts, who, upon sensing a unique moment tries to capture an image of something that other cultures (especially ours) could indeed learn much from.

Come winter, there is something magical in falling snow as it surrounds each and every twig with a mantle of white silence. Soon every man-made desecration is awash in white. That horse and buggy you could usually hear from a half mile away is now almost upon you, and only the sound of steam escaping from the horse's nostrils signals its presence.

After a goodly blanket of white down has fallen, the landscape is barely visible and hardly the same—and neither are you.

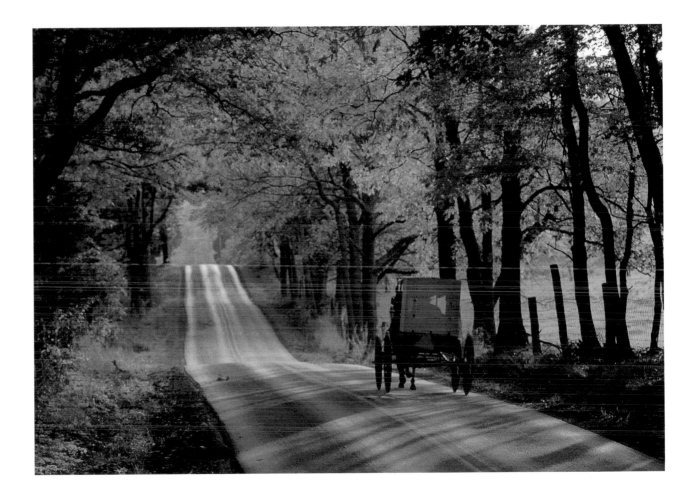

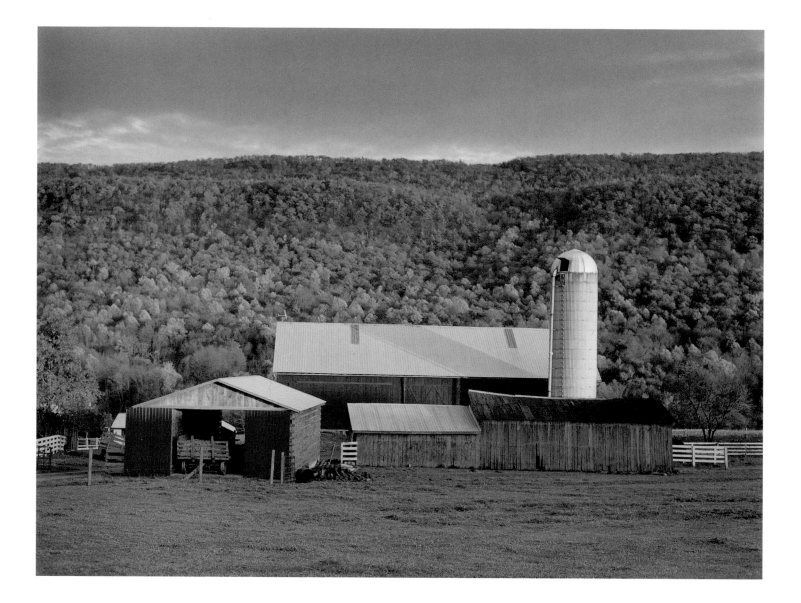

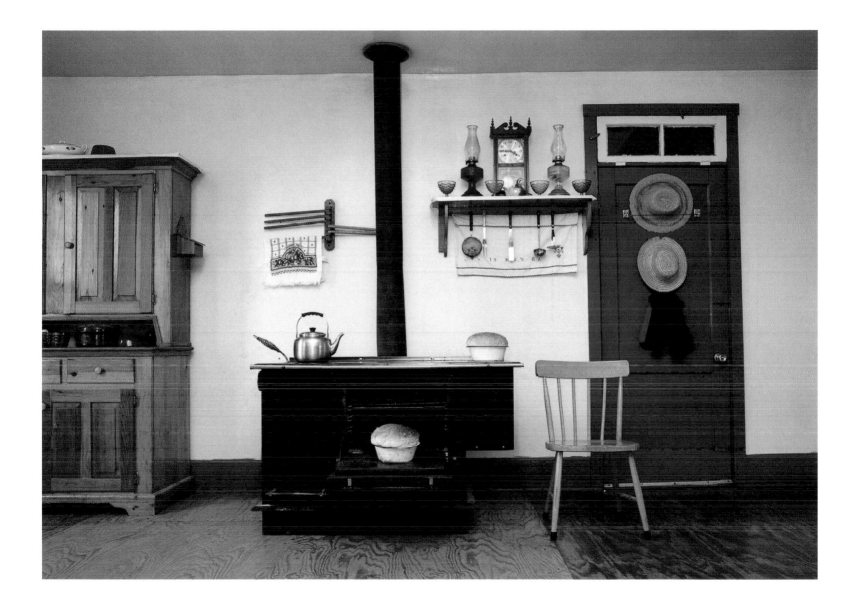

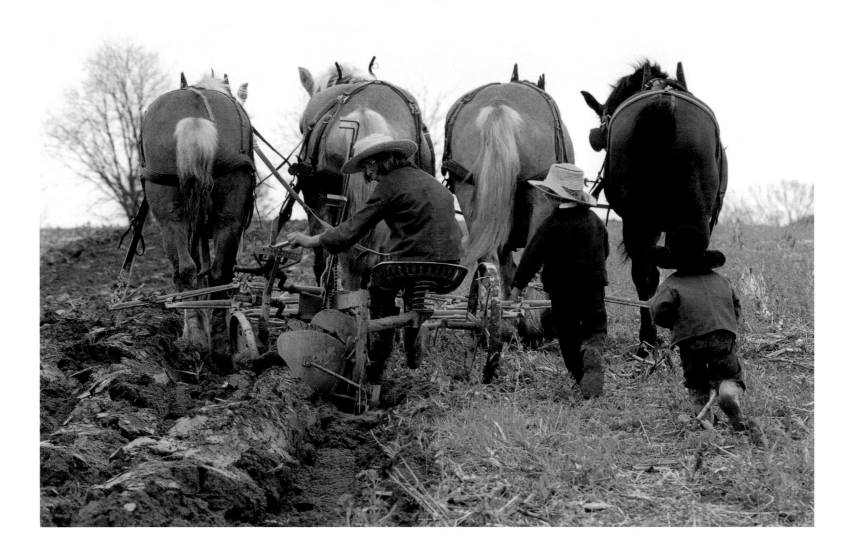

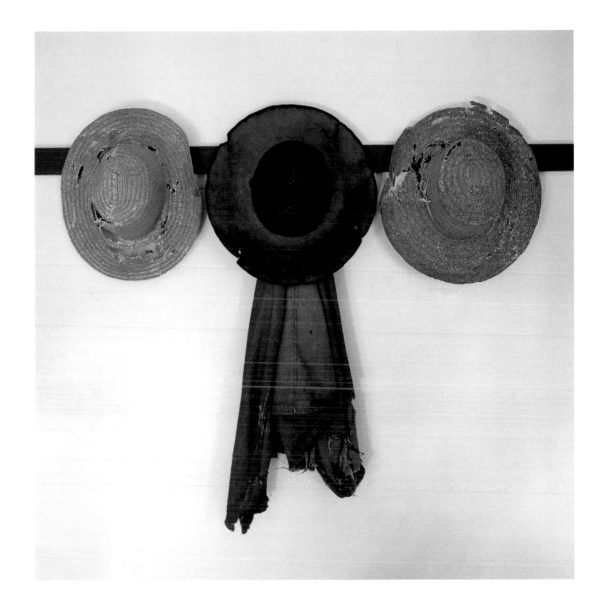

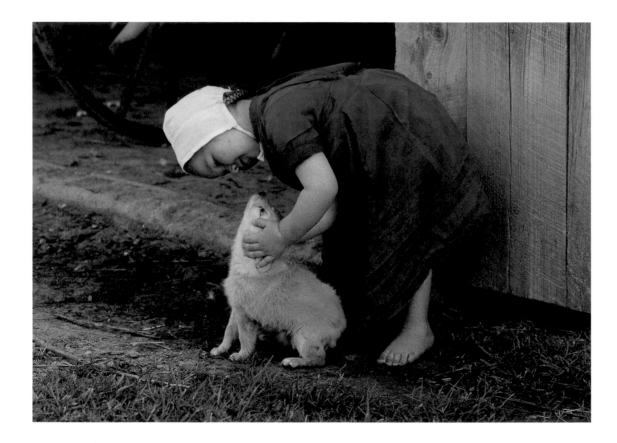

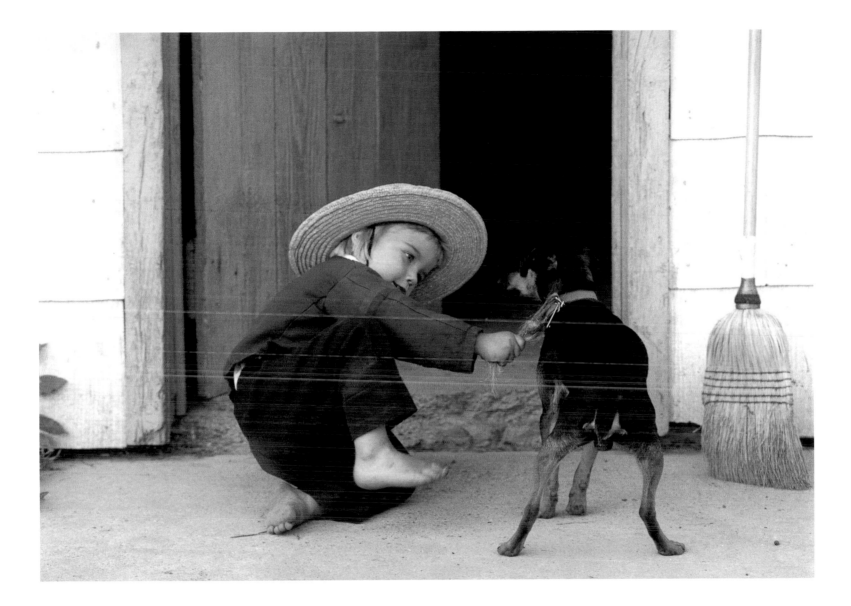

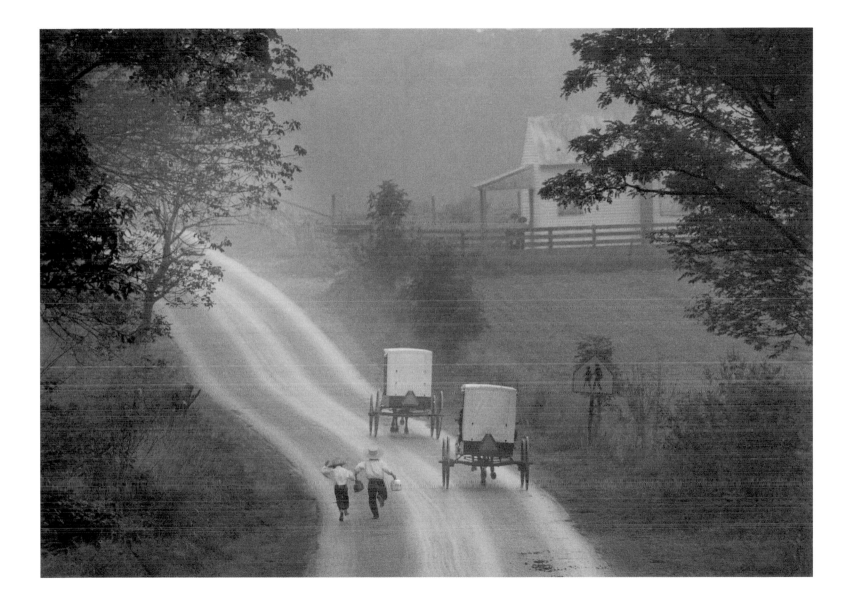

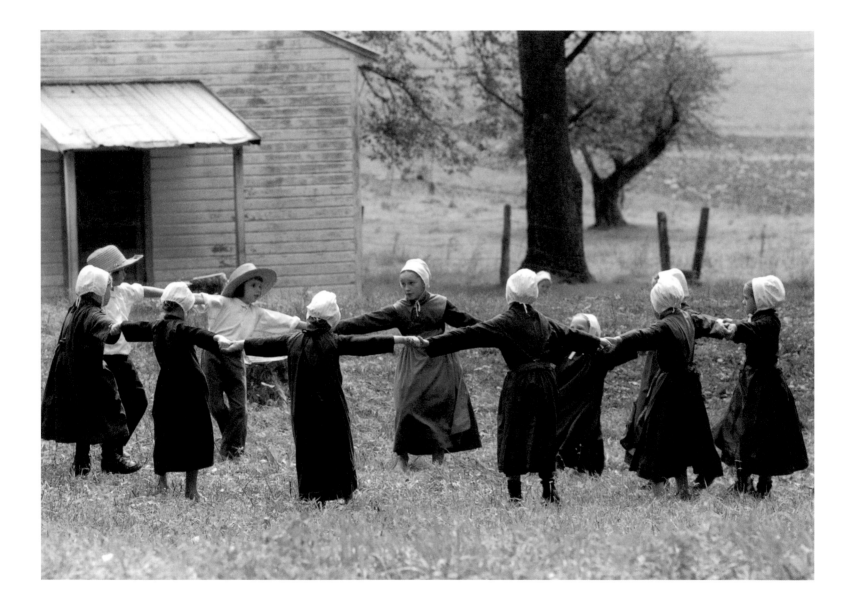

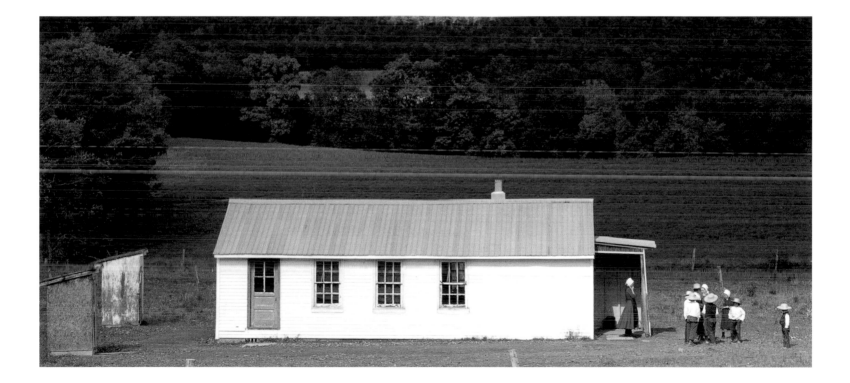

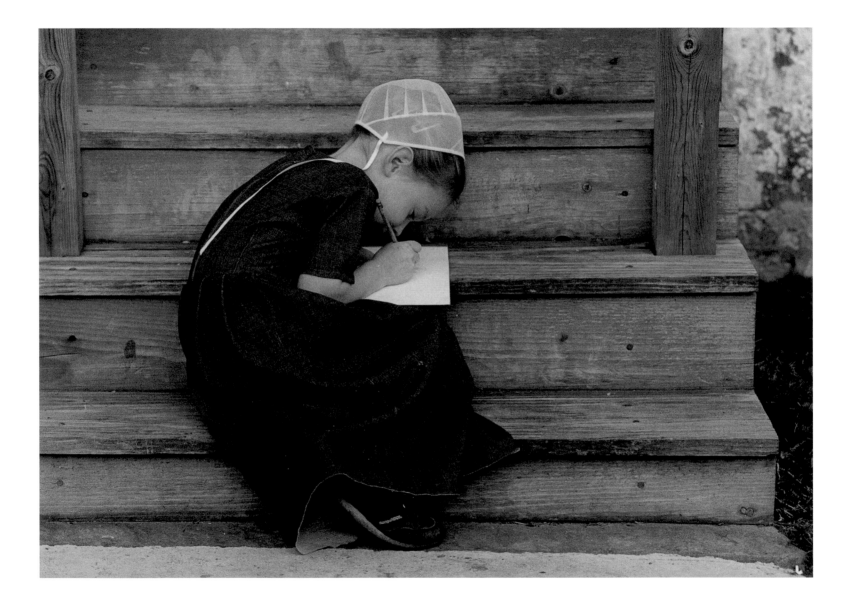

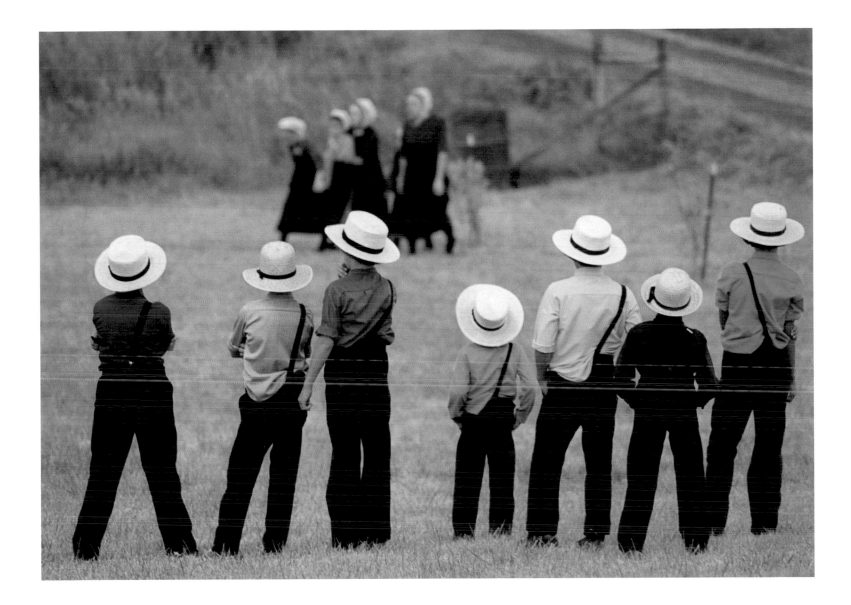

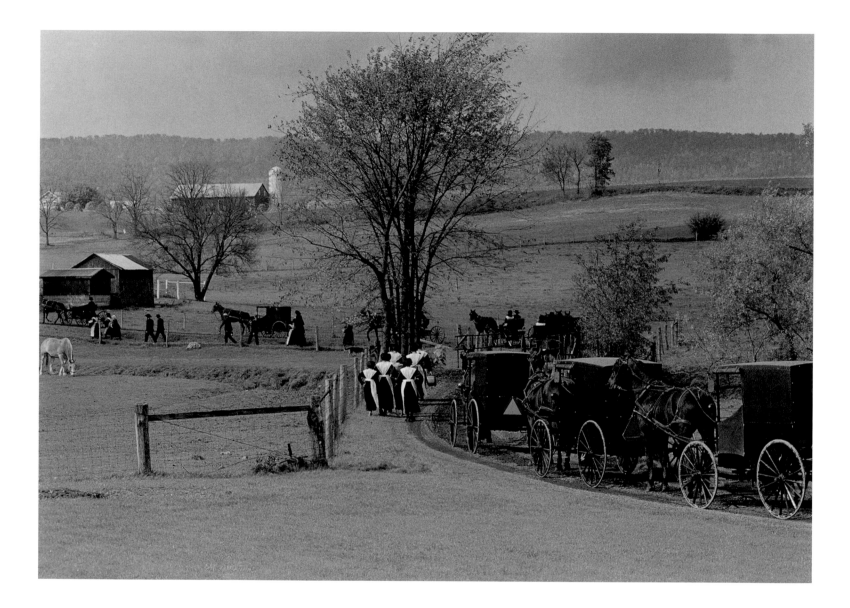

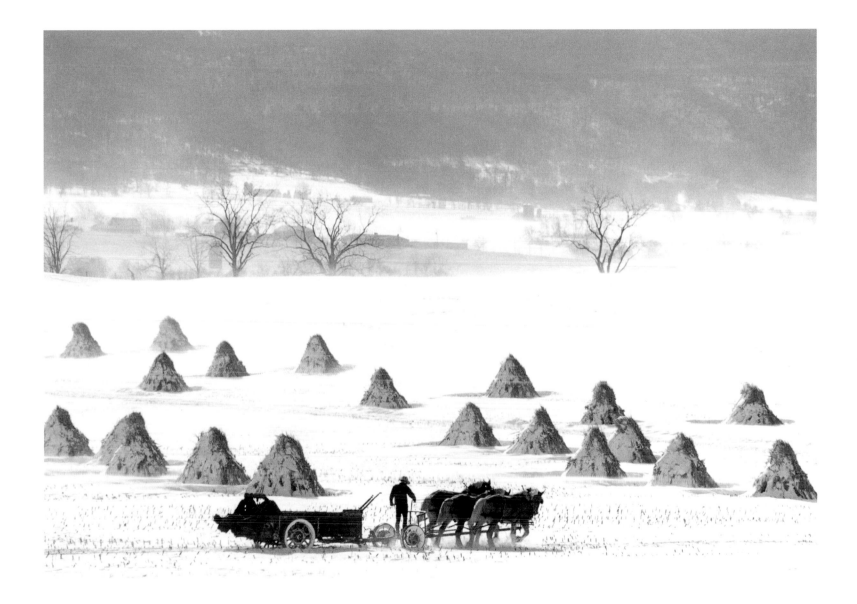

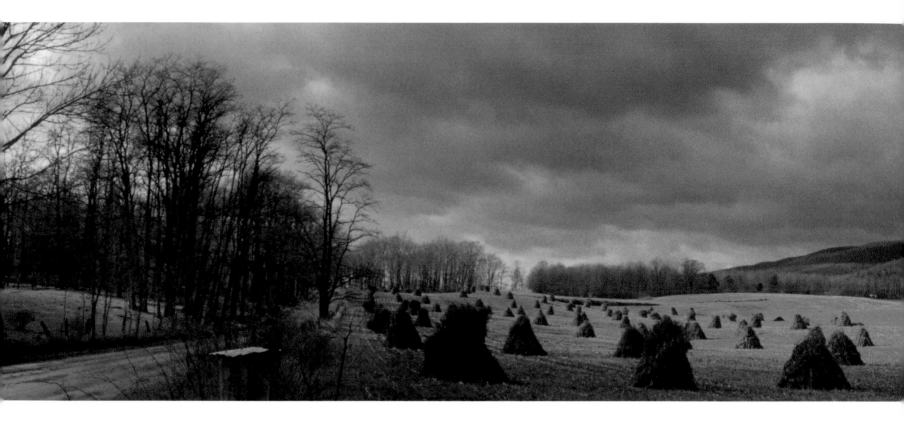

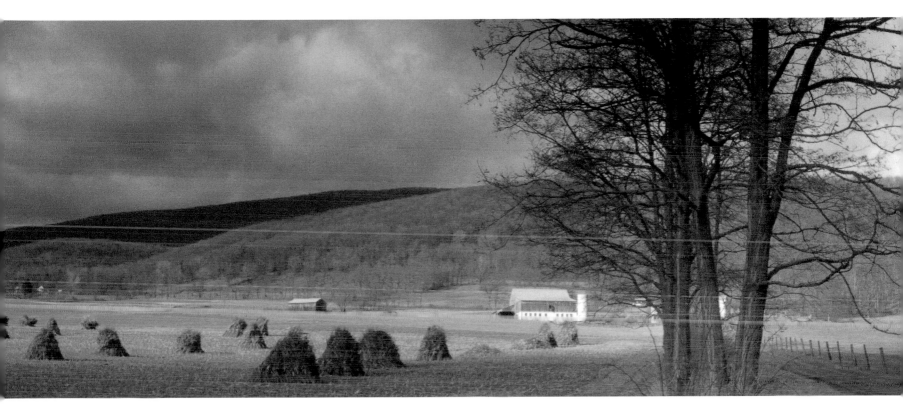

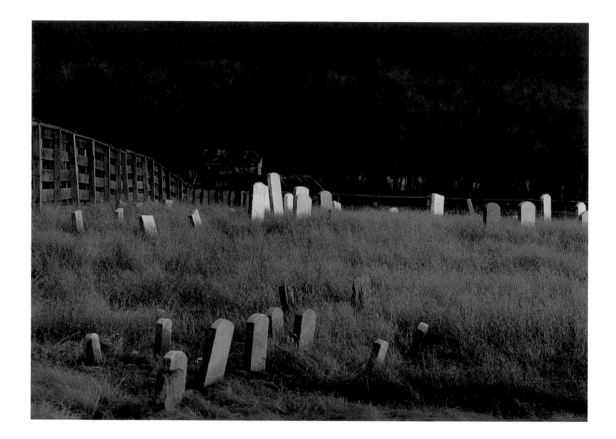

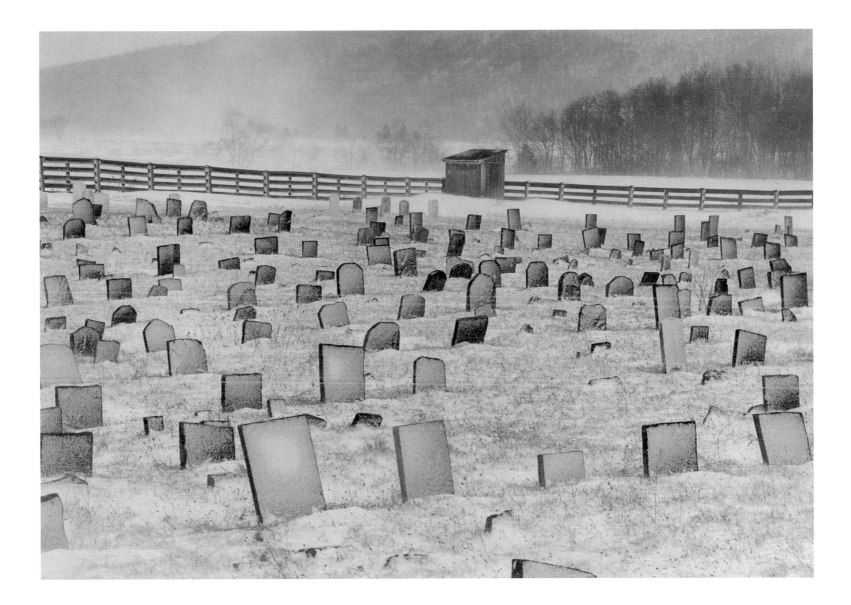

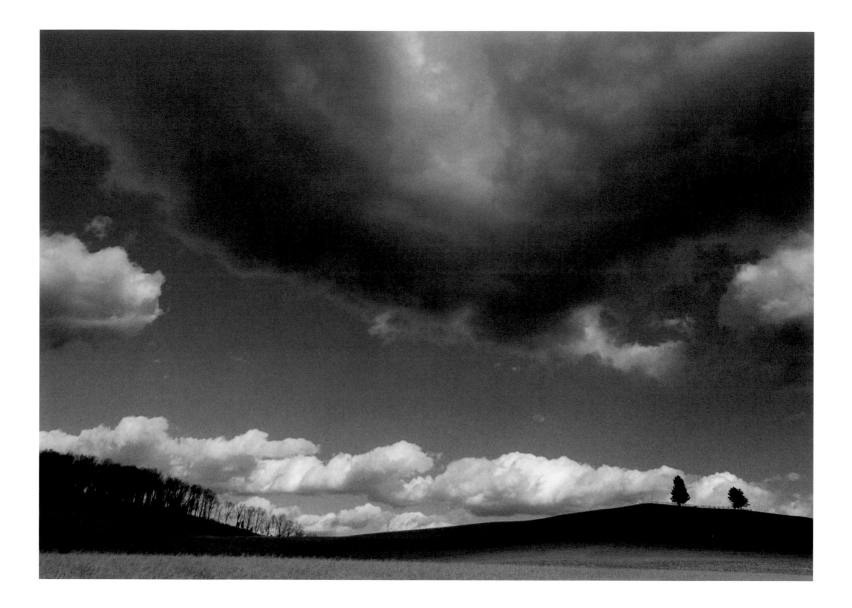

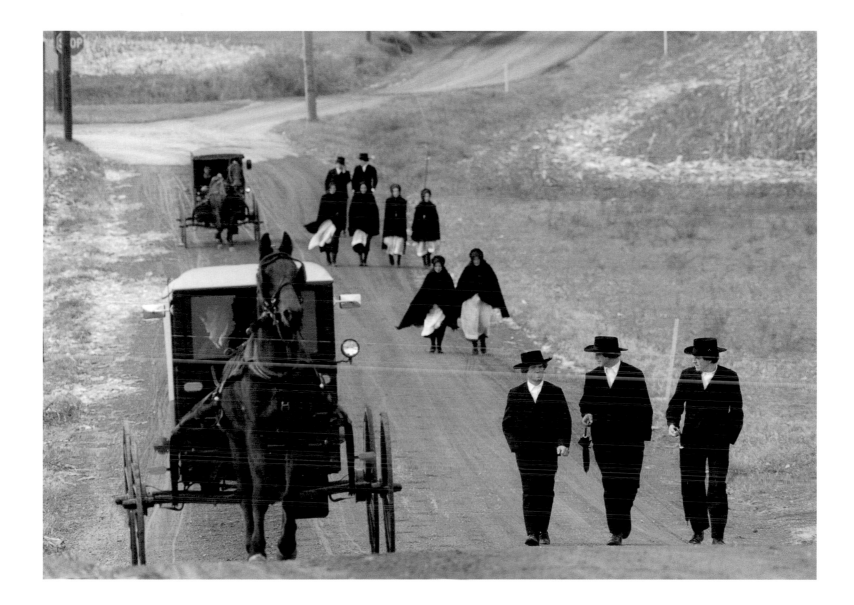

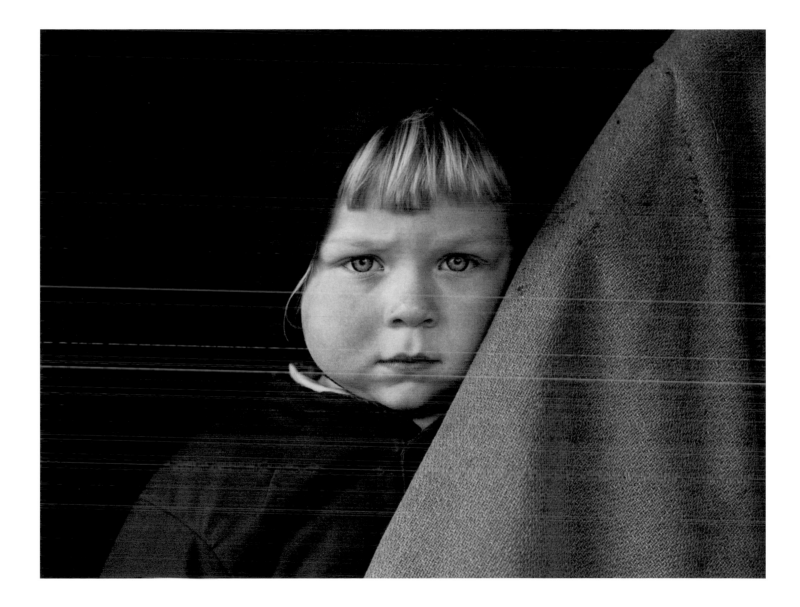

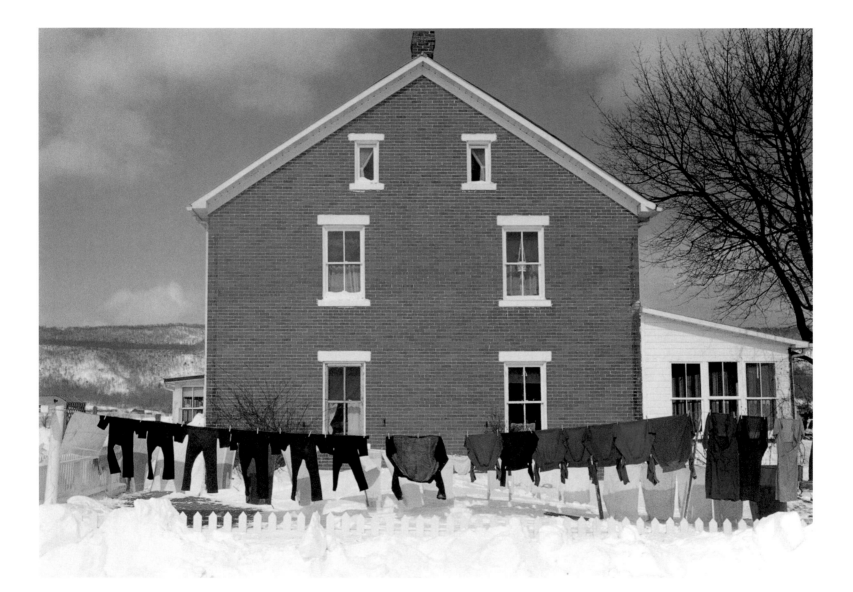

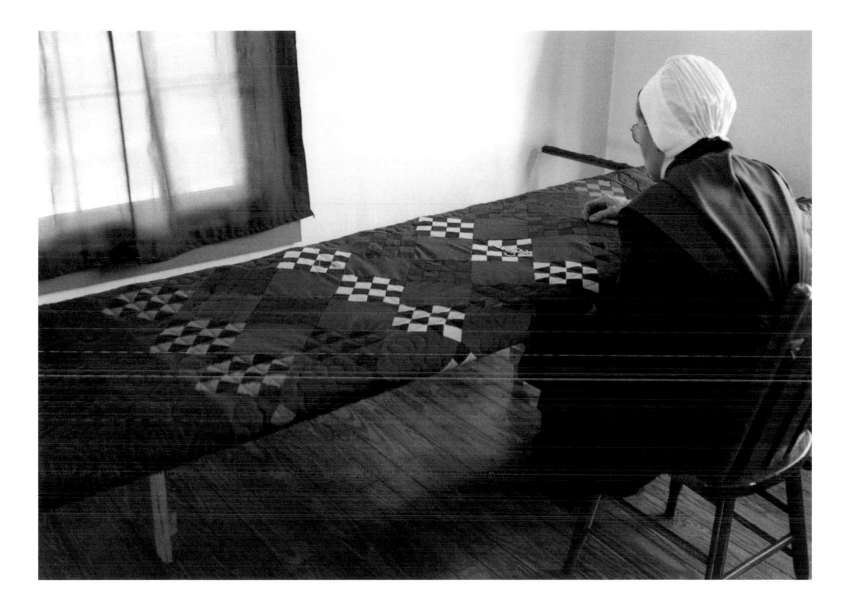

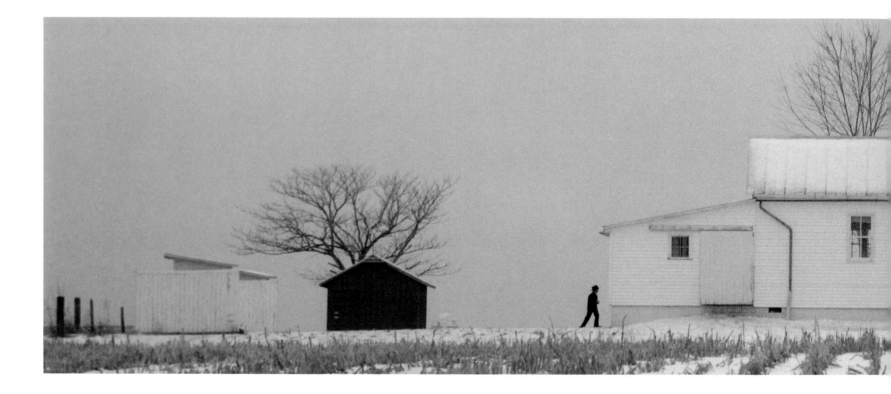

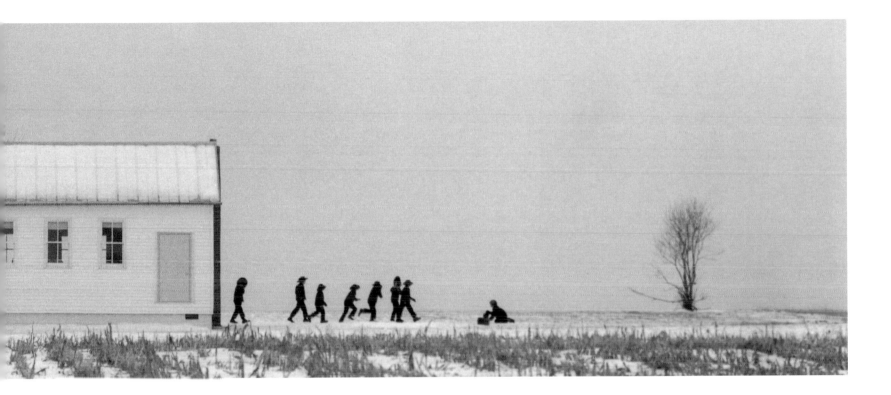

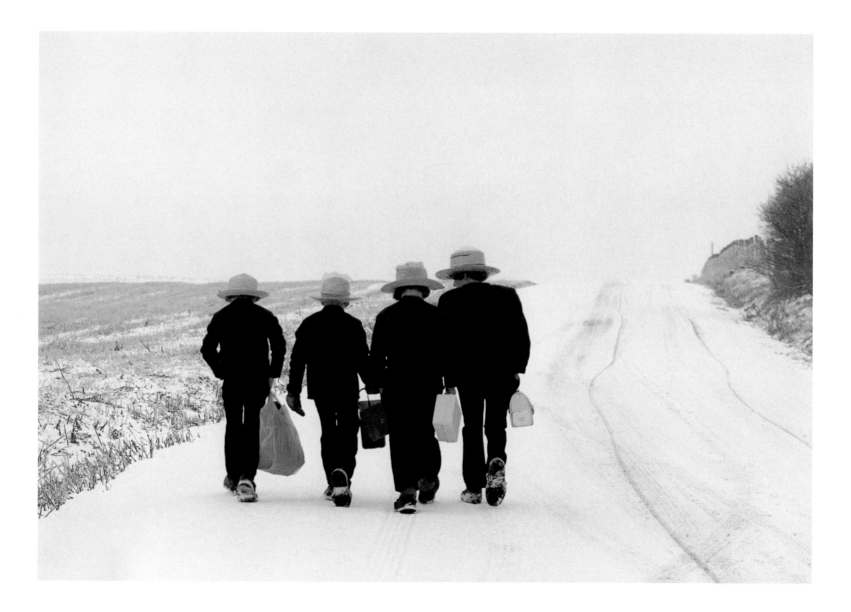

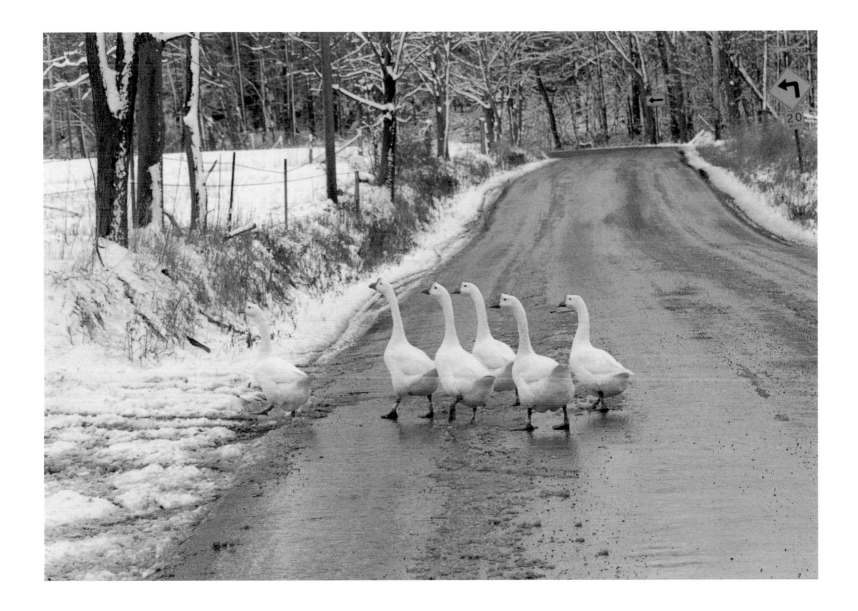

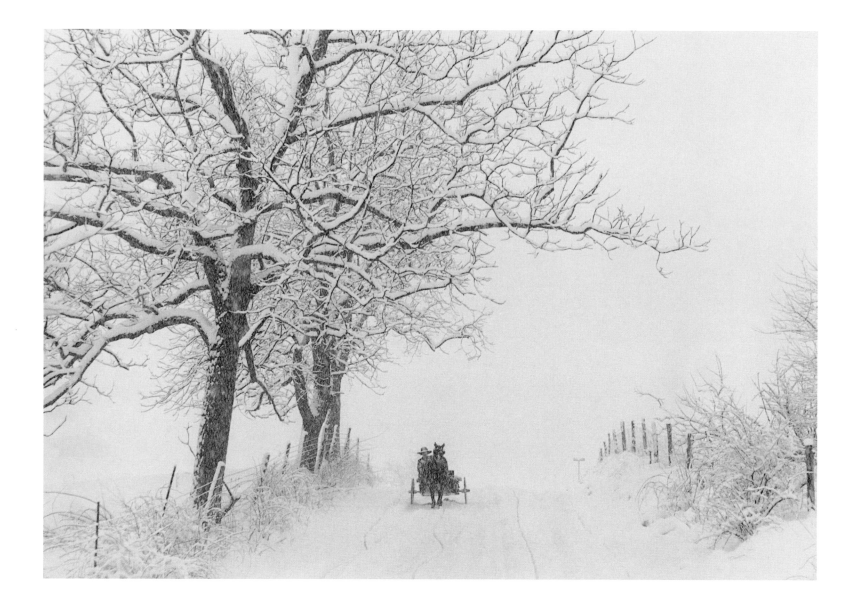

42

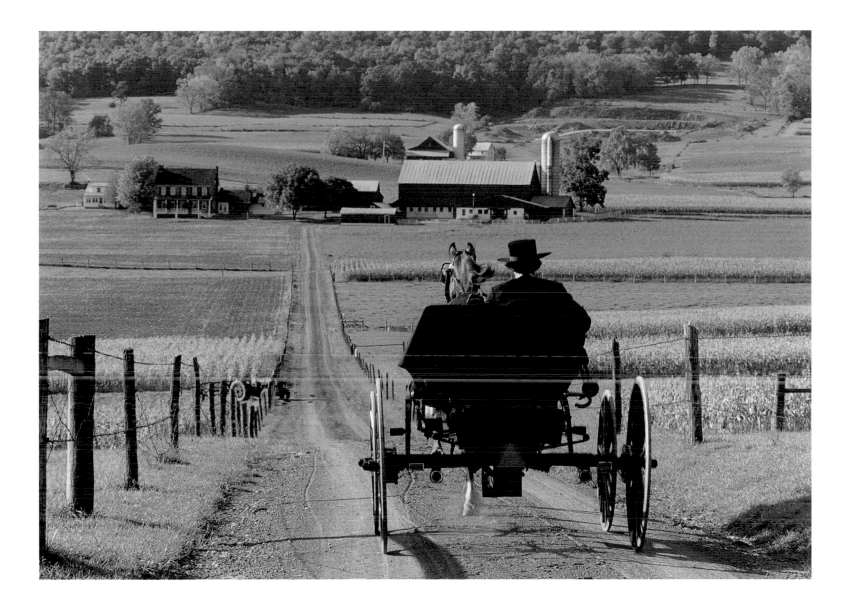

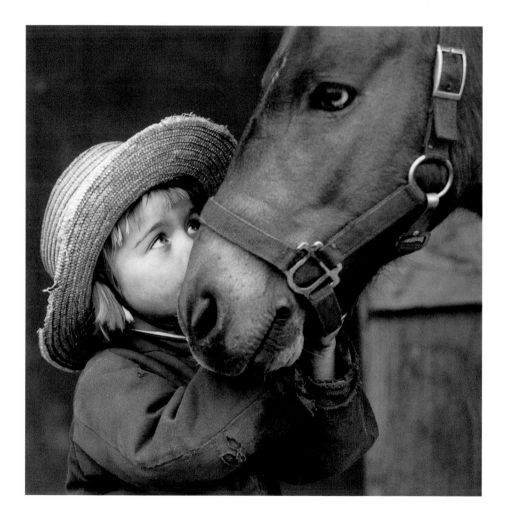

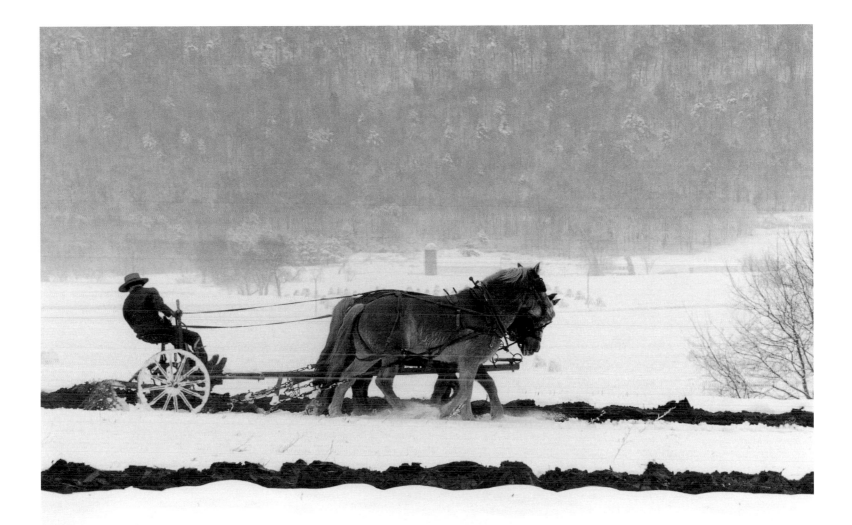

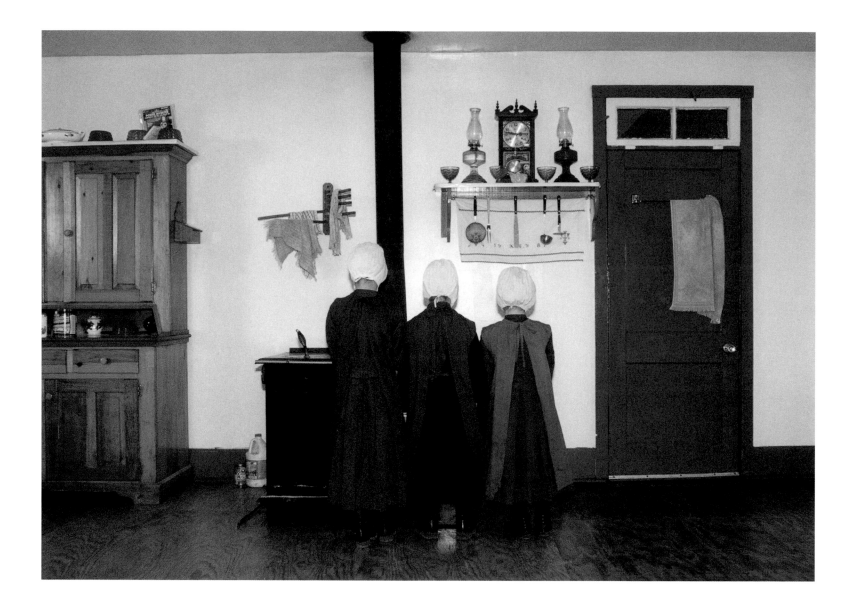

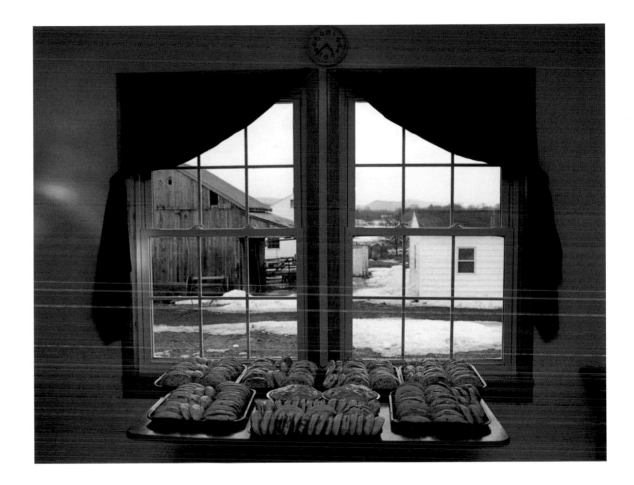

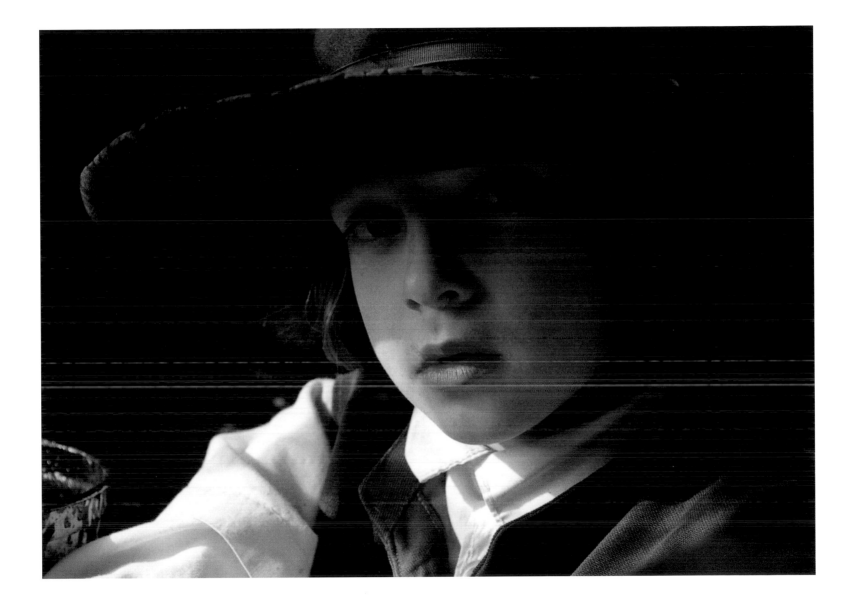

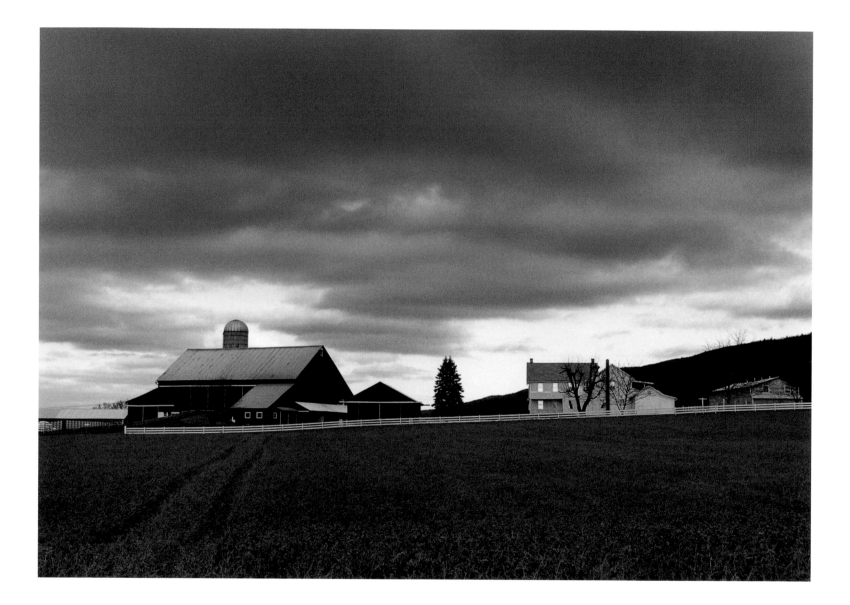

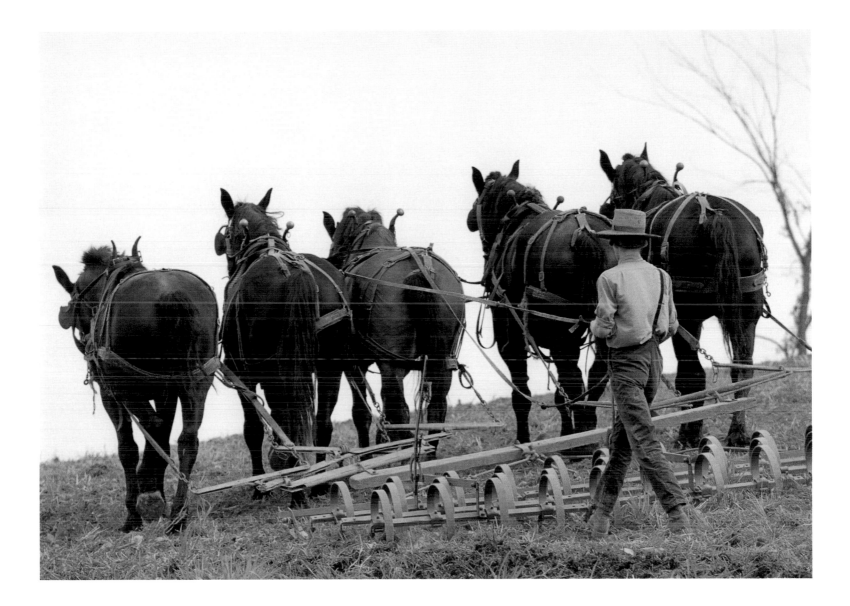

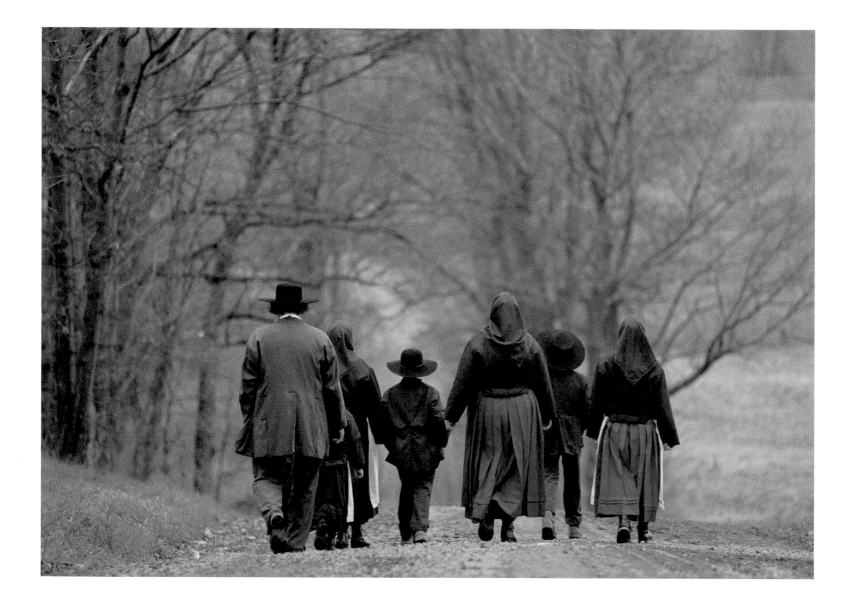

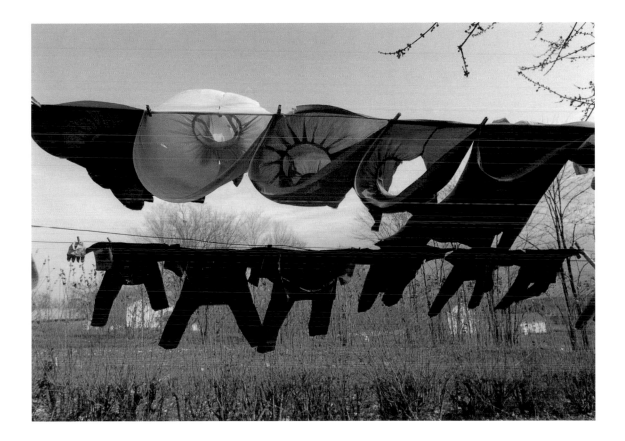

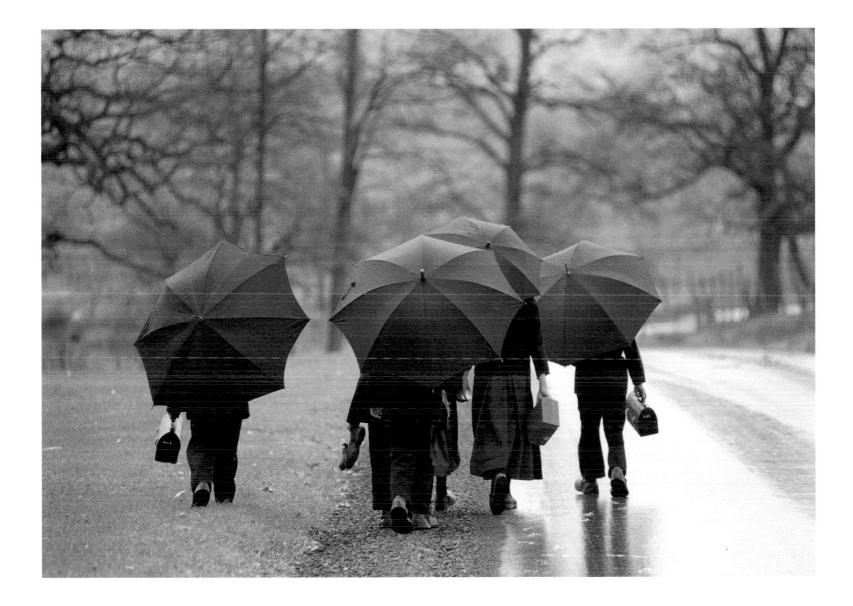

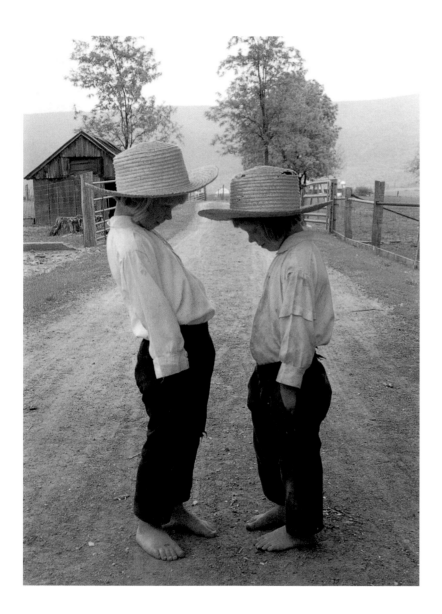

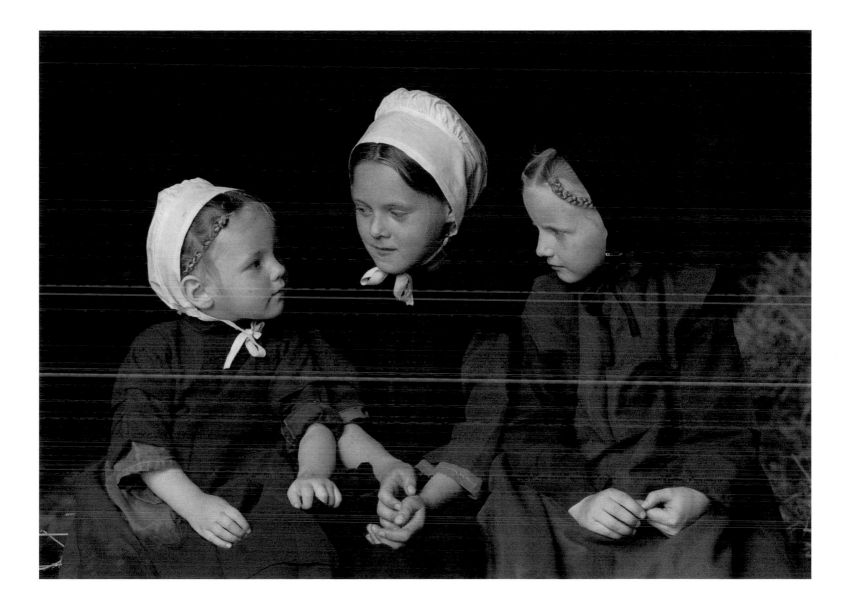

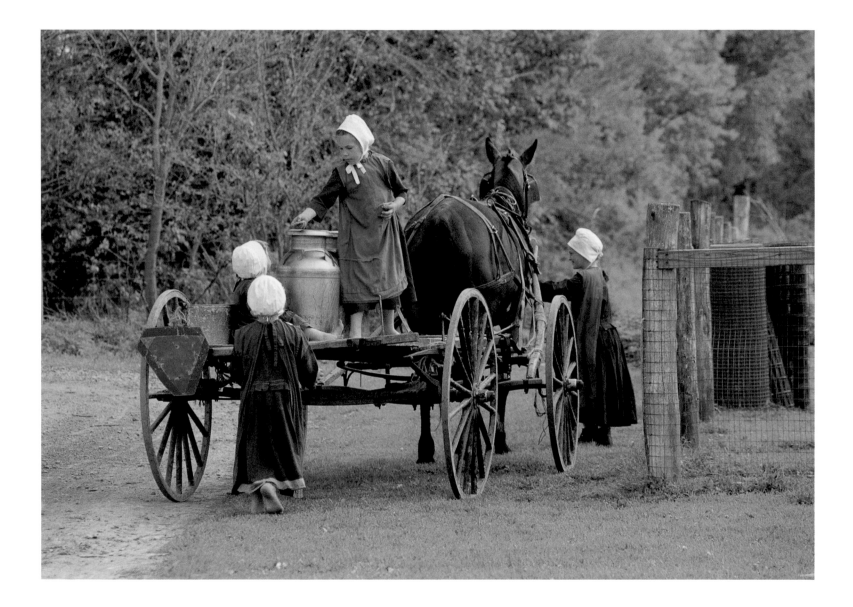

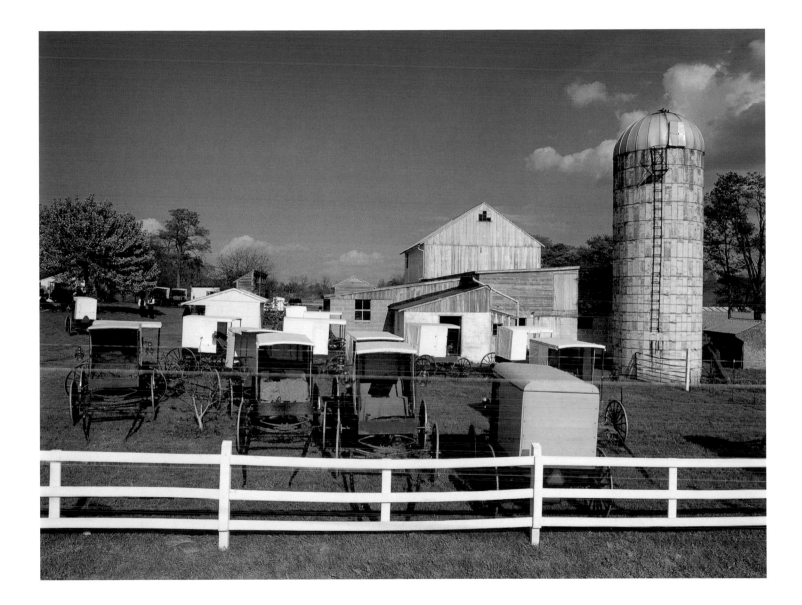

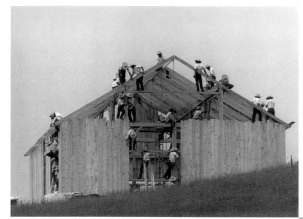

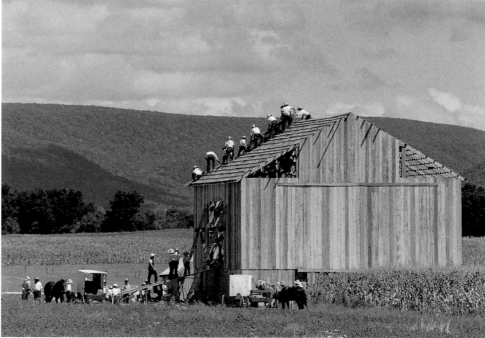

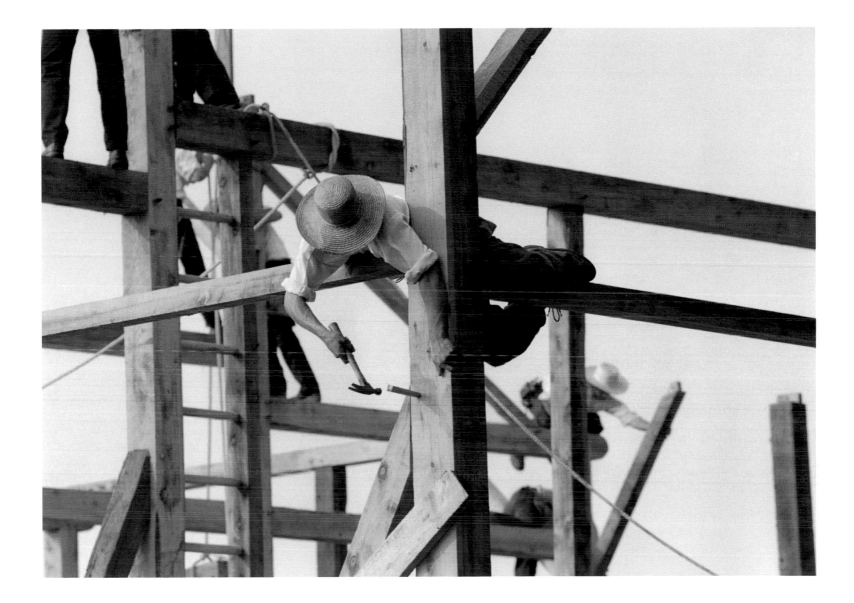

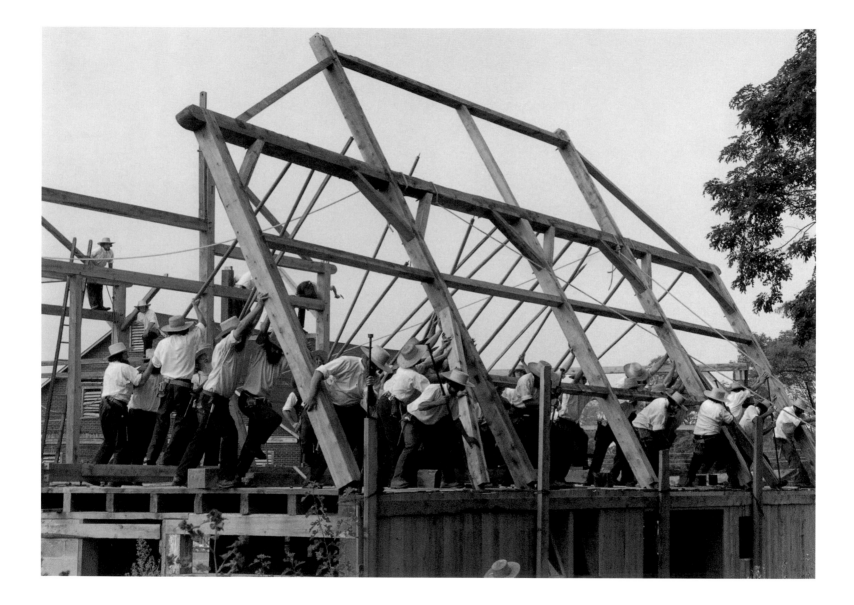

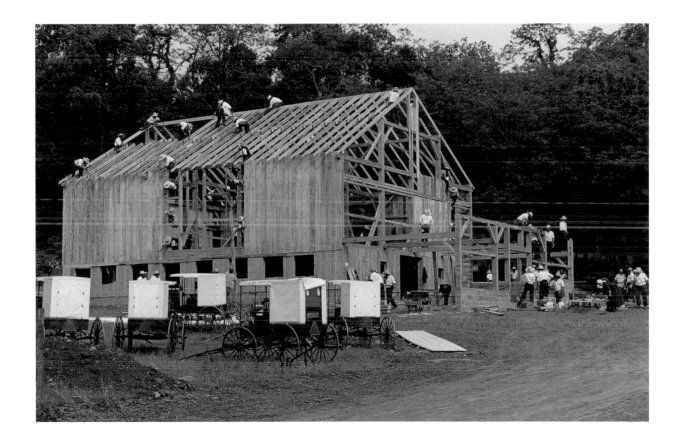

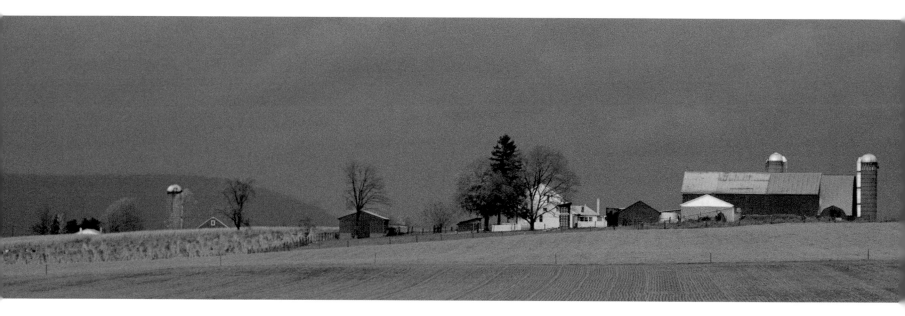

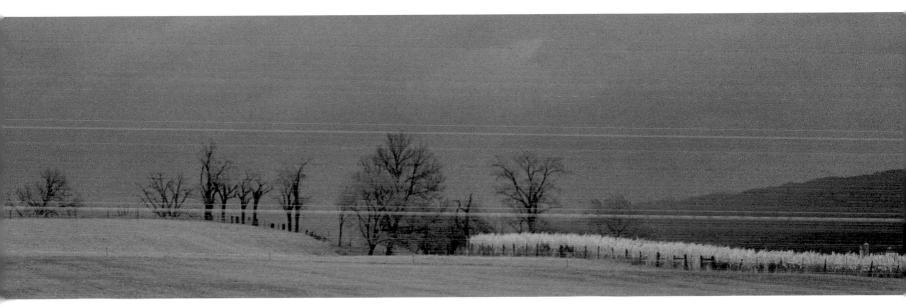

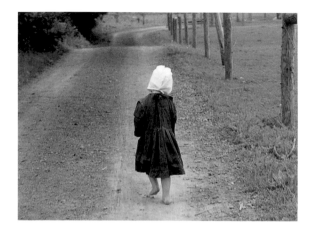

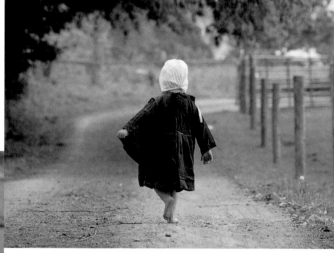

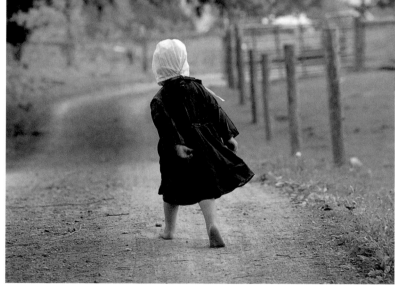

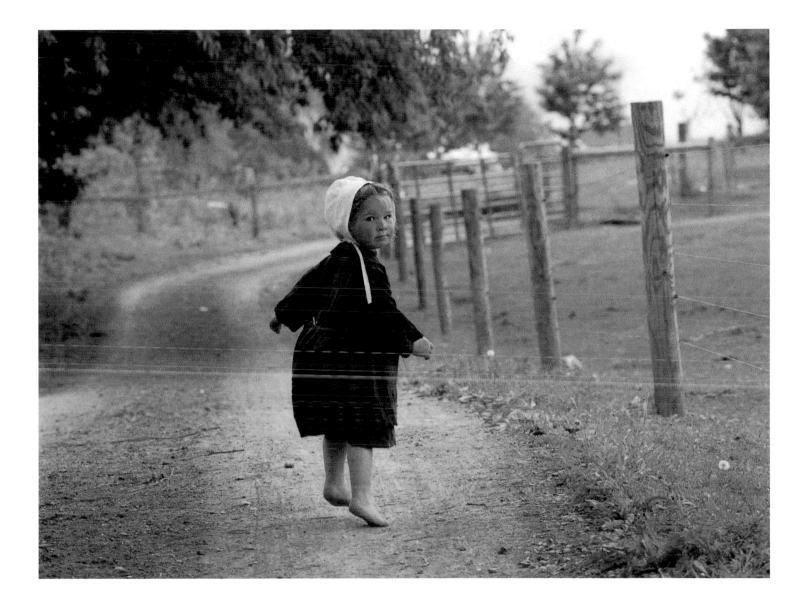

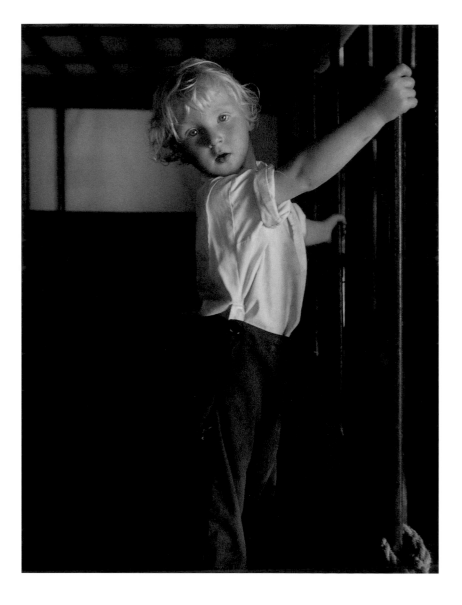

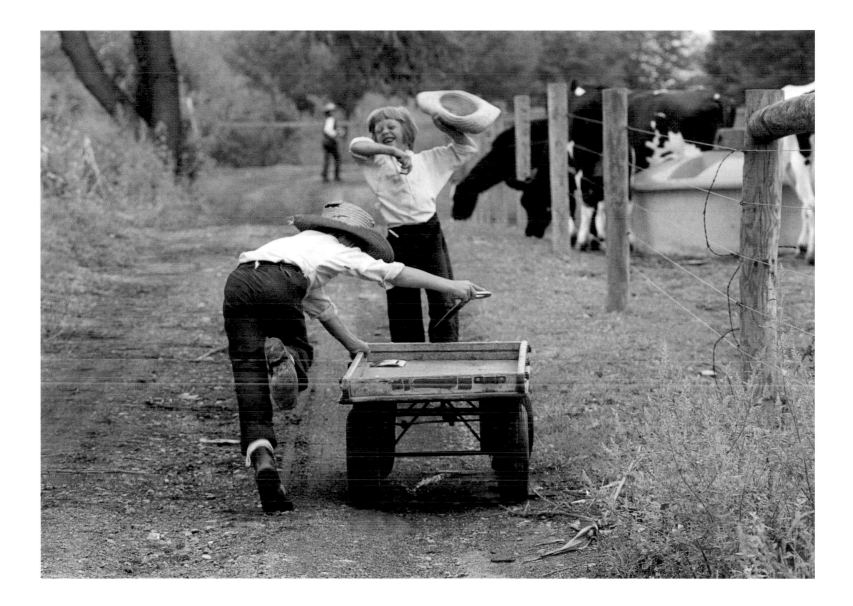

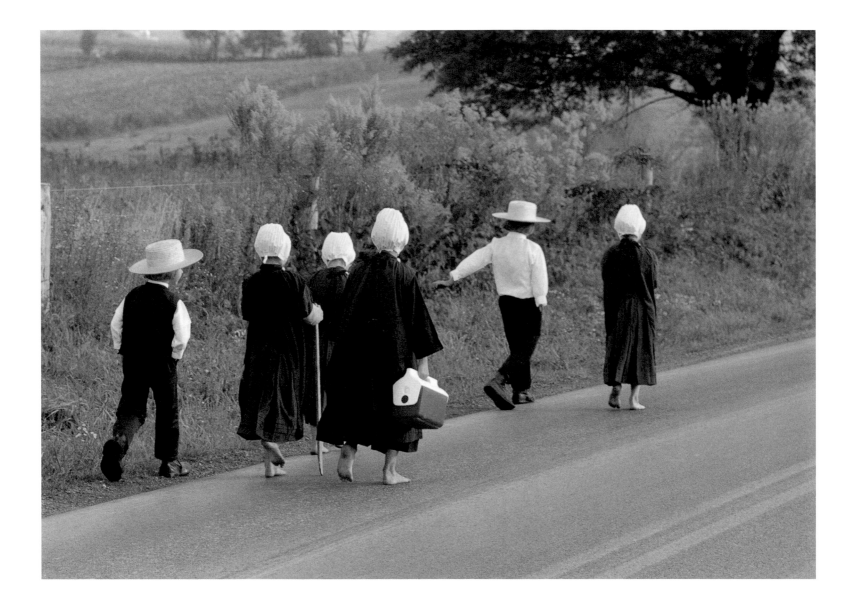

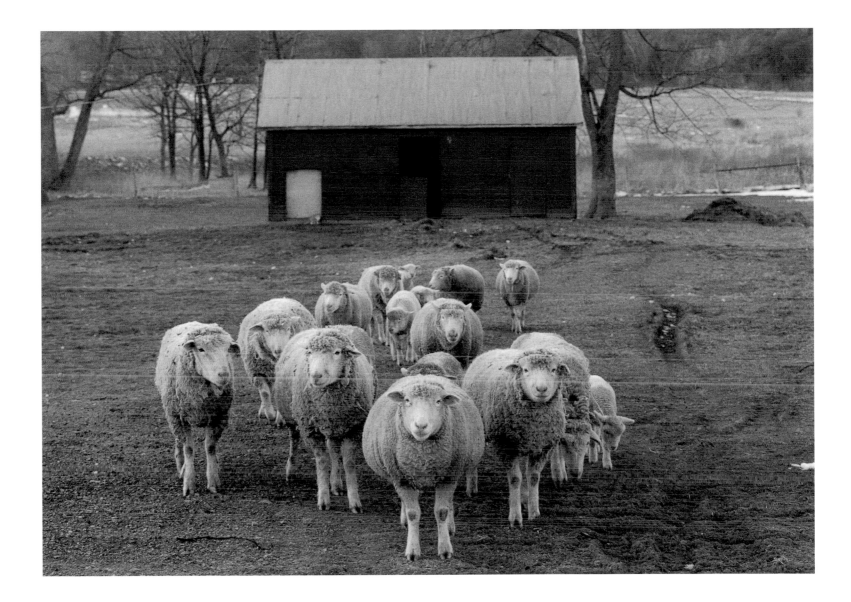

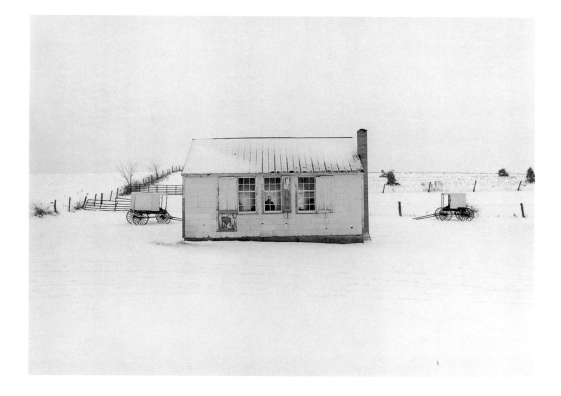

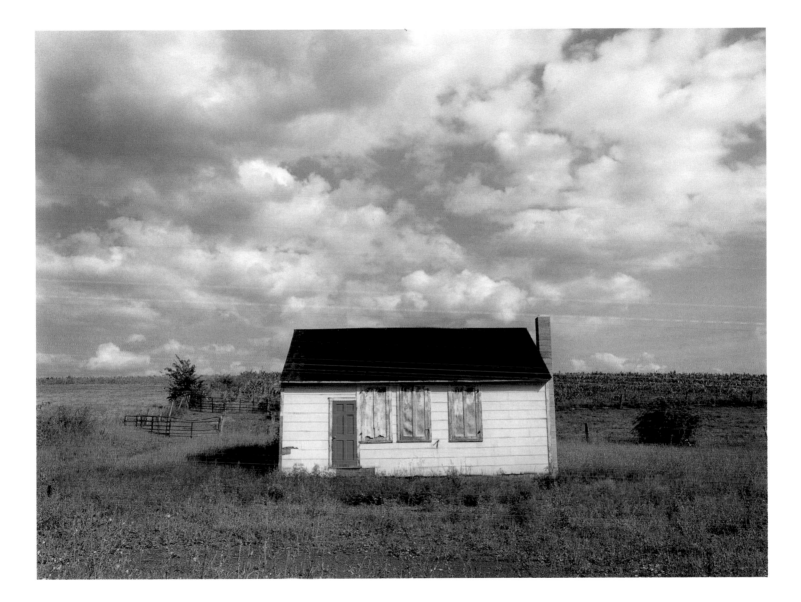

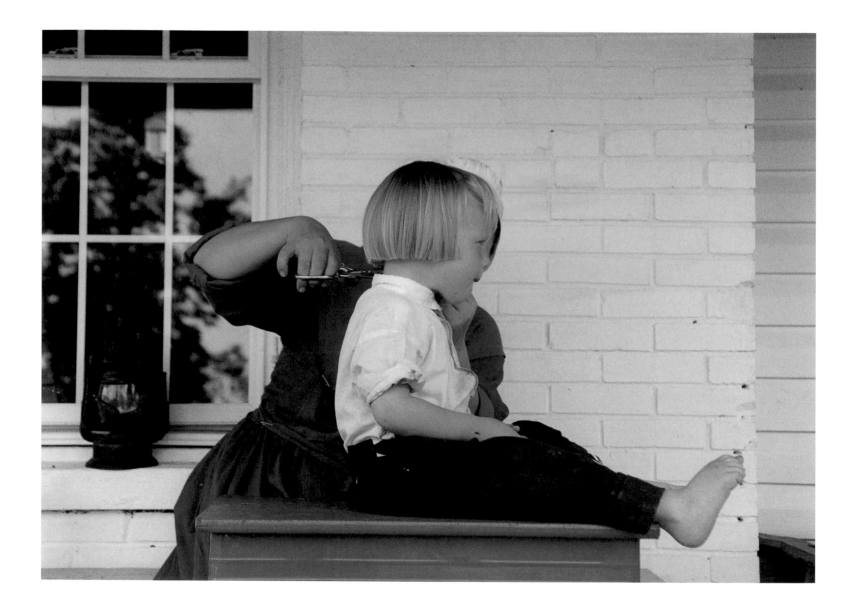

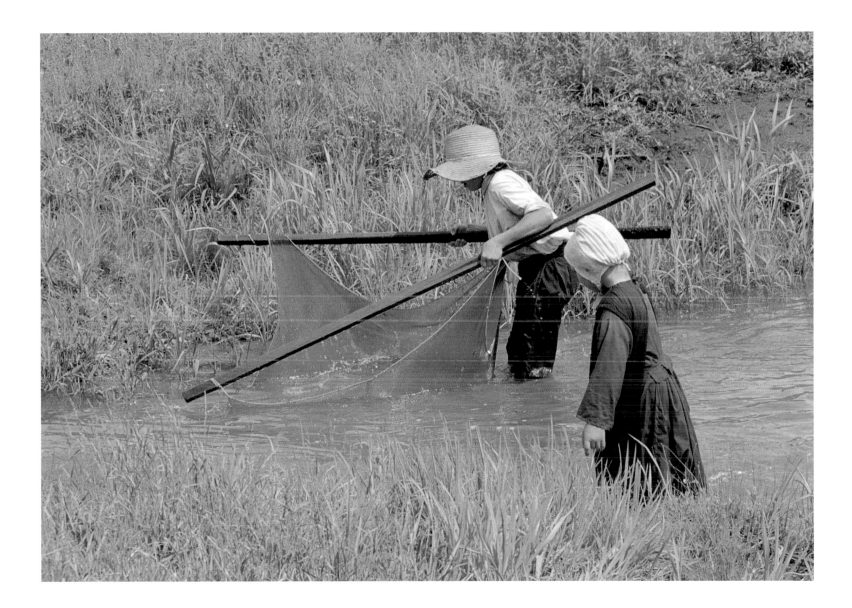

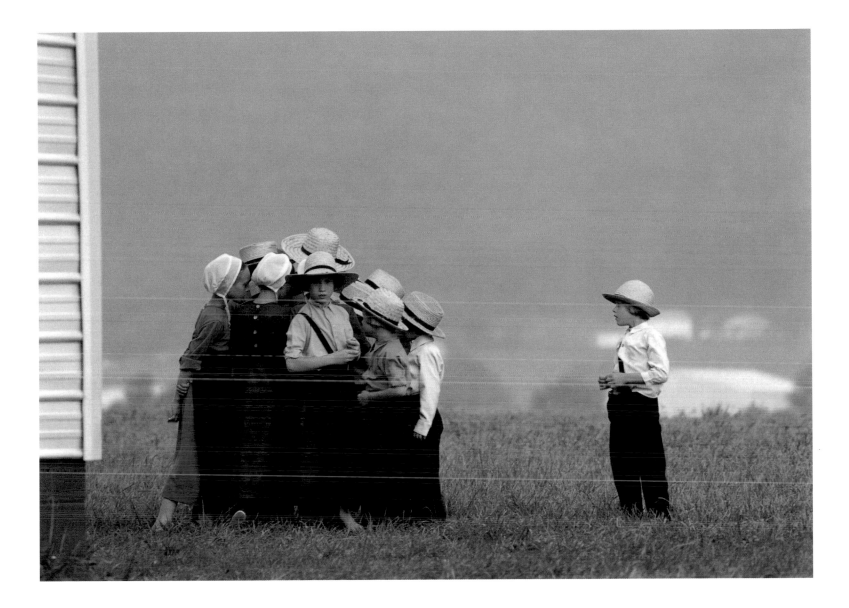

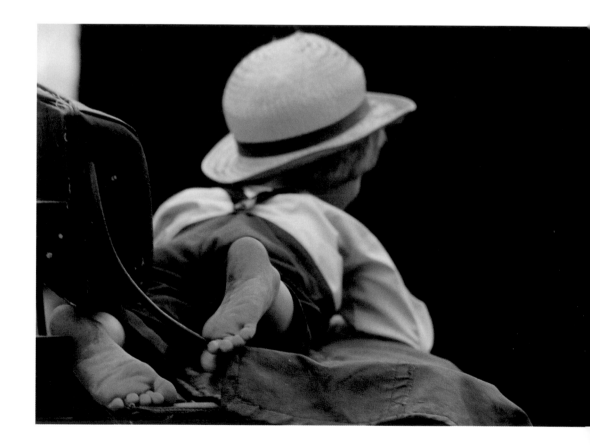

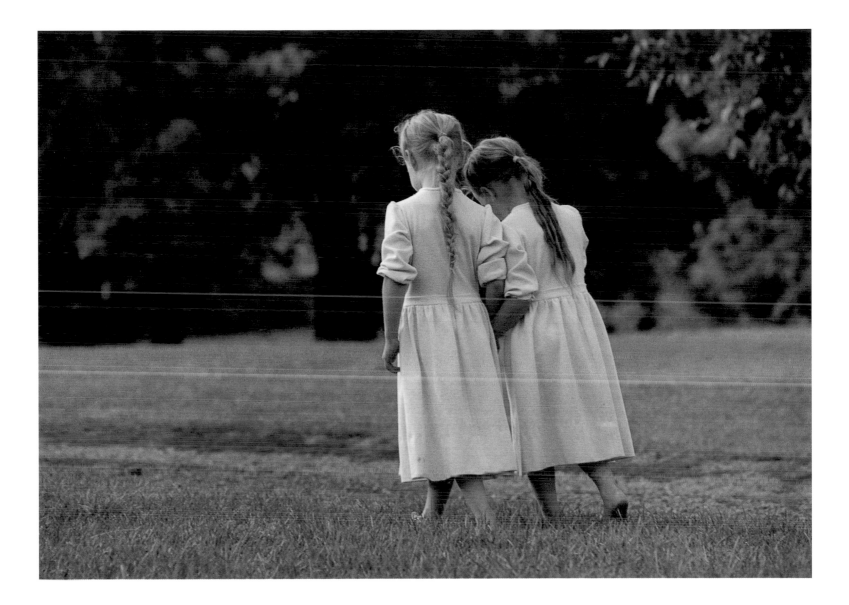

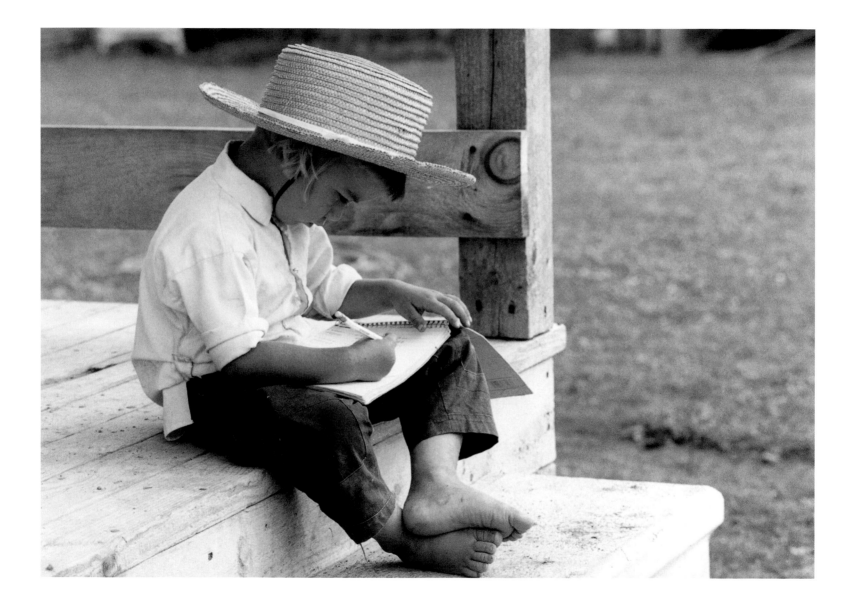

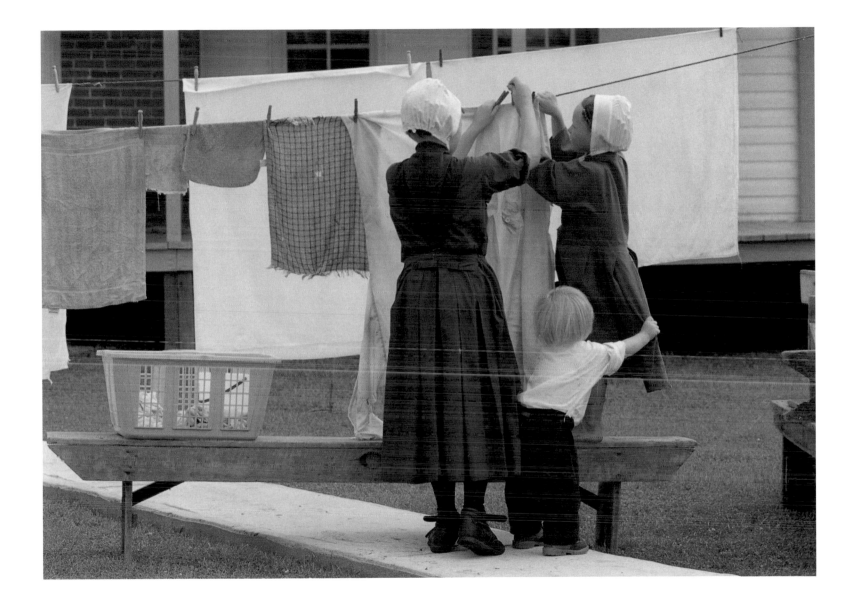

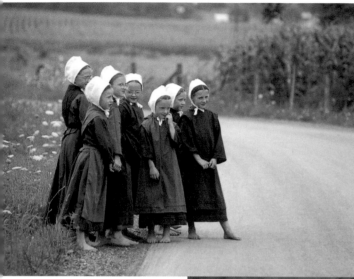

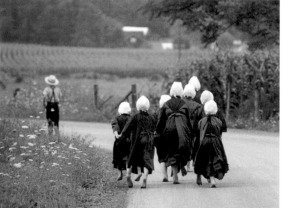

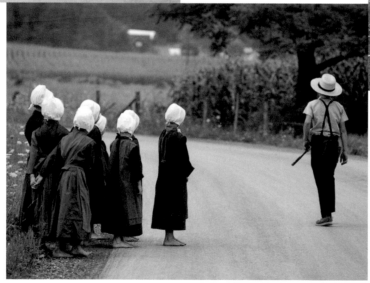

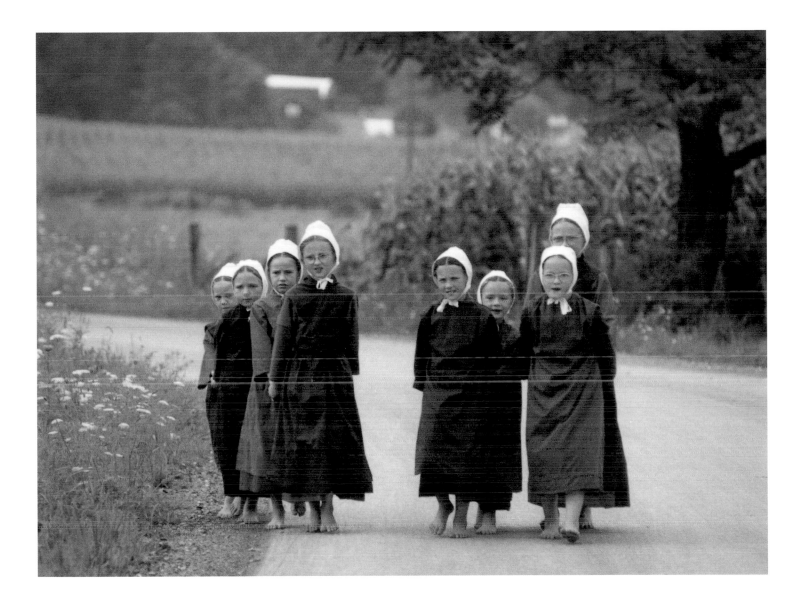

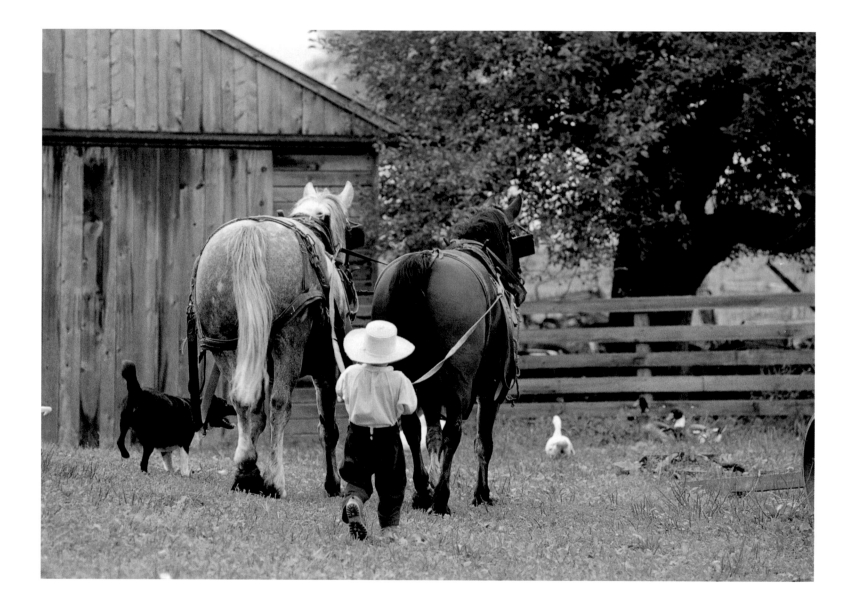

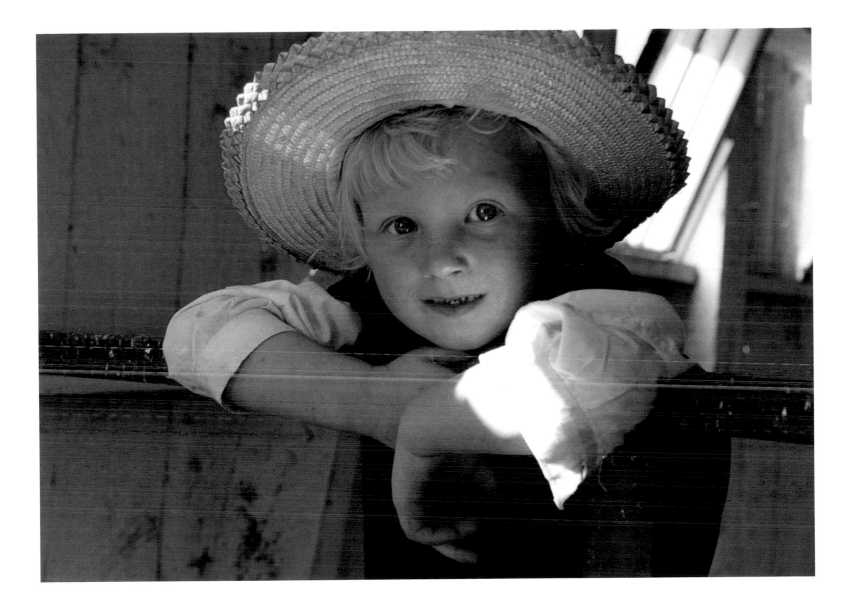

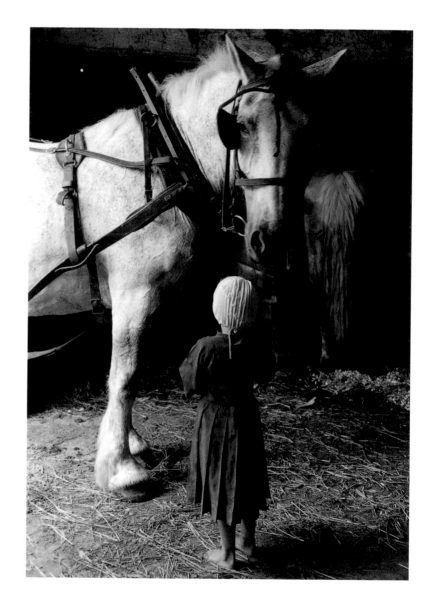

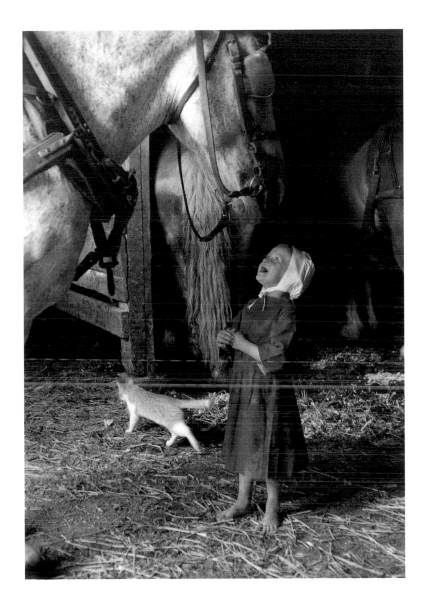

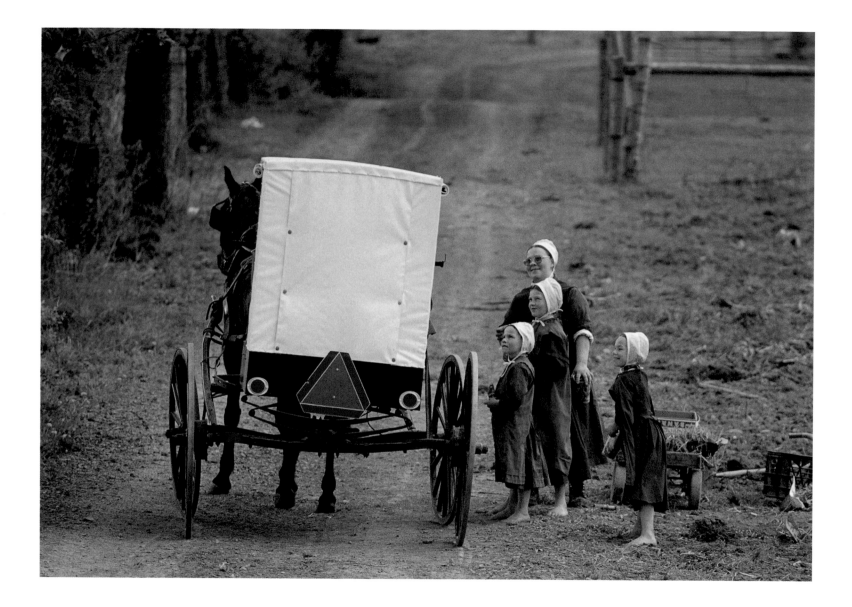

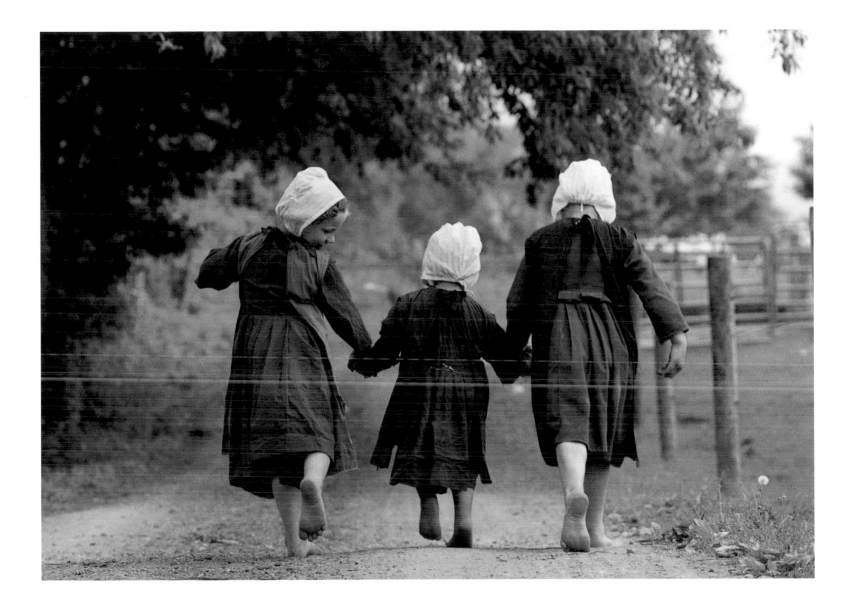

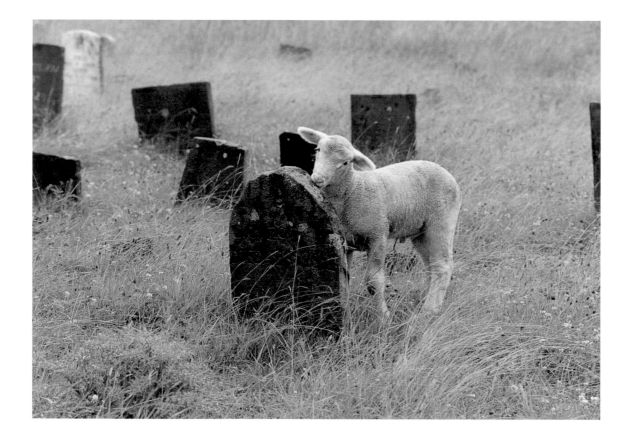

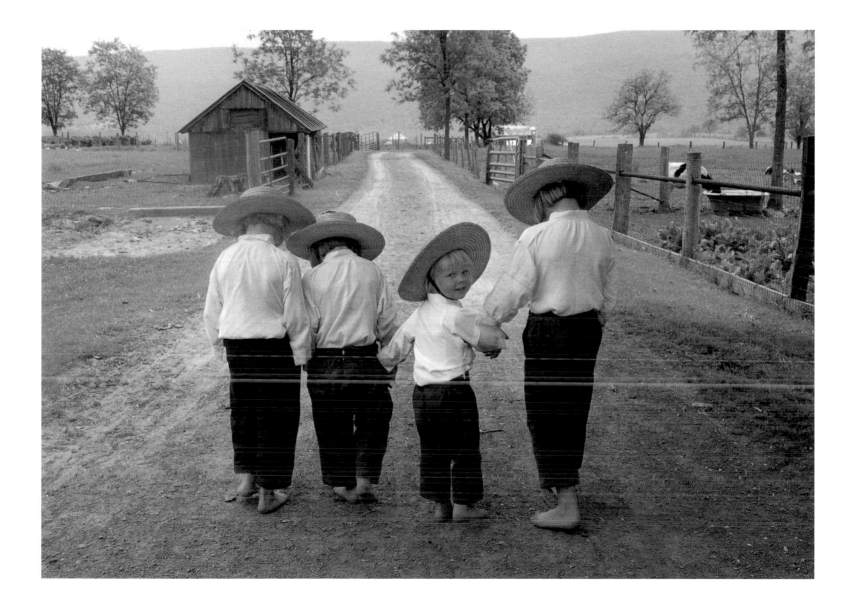

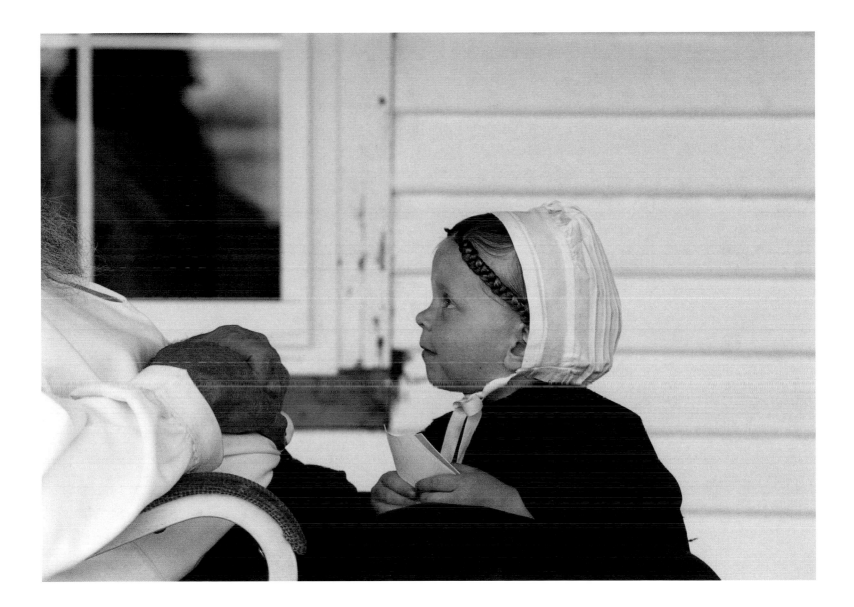

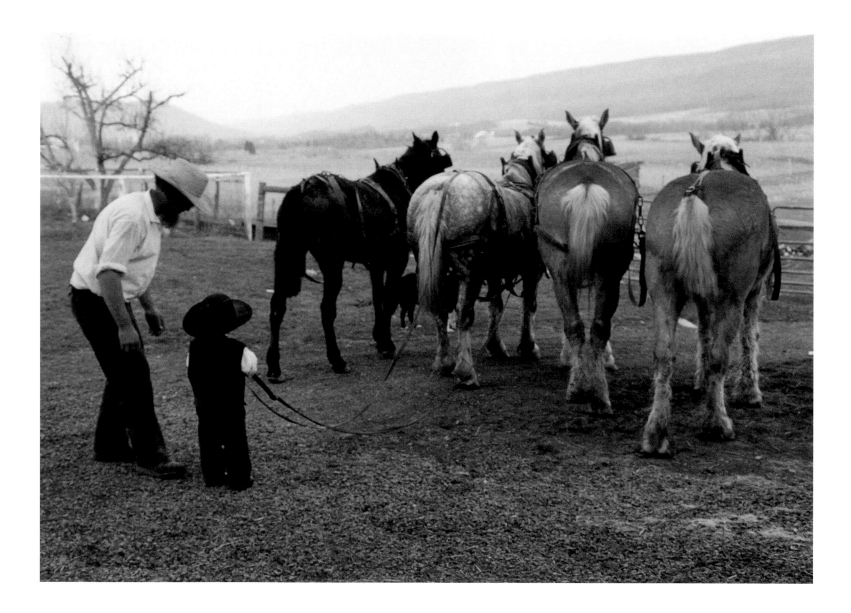

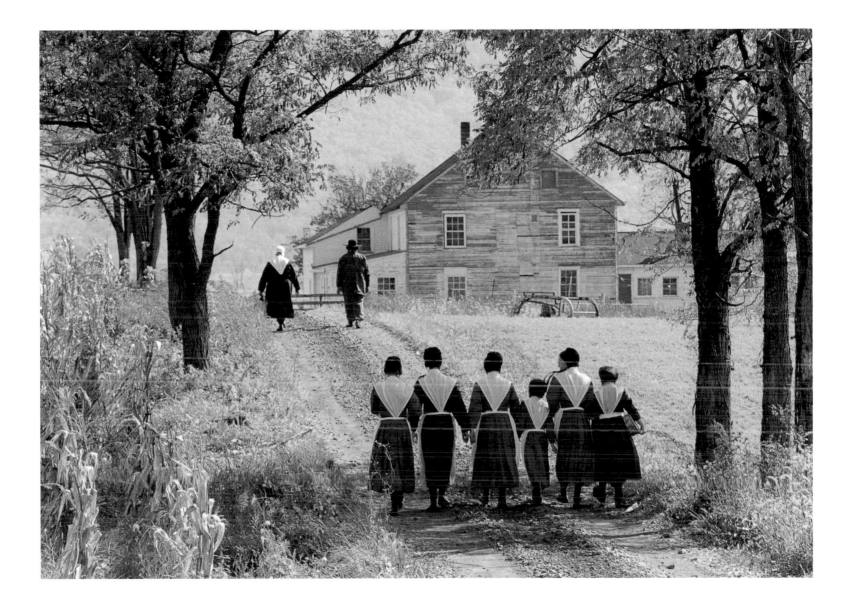

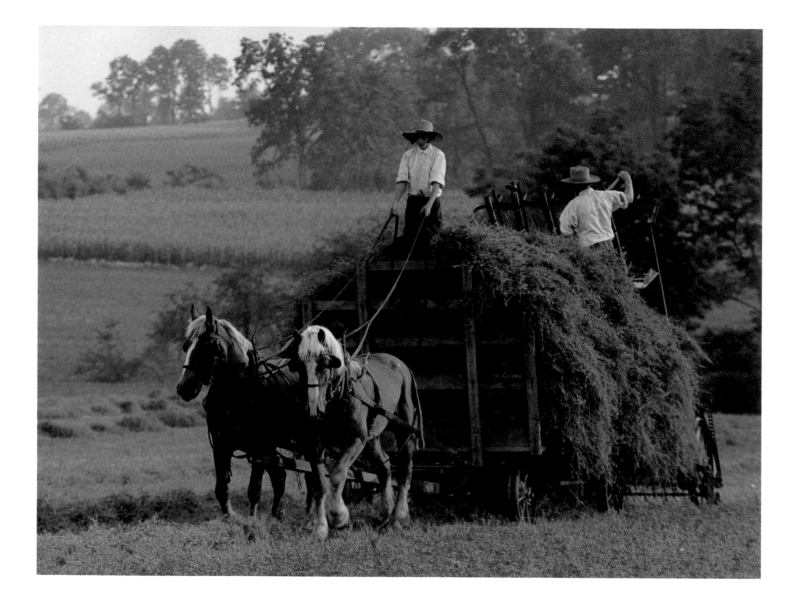

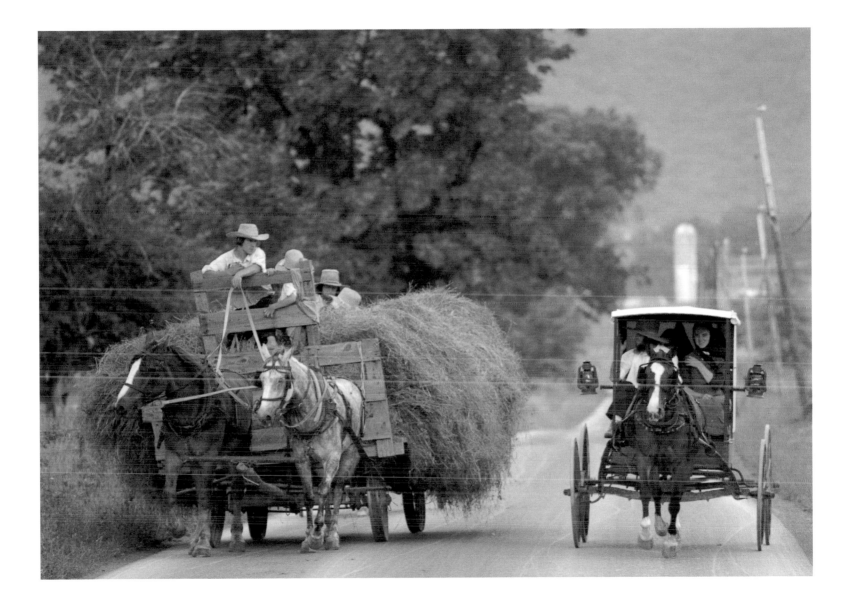

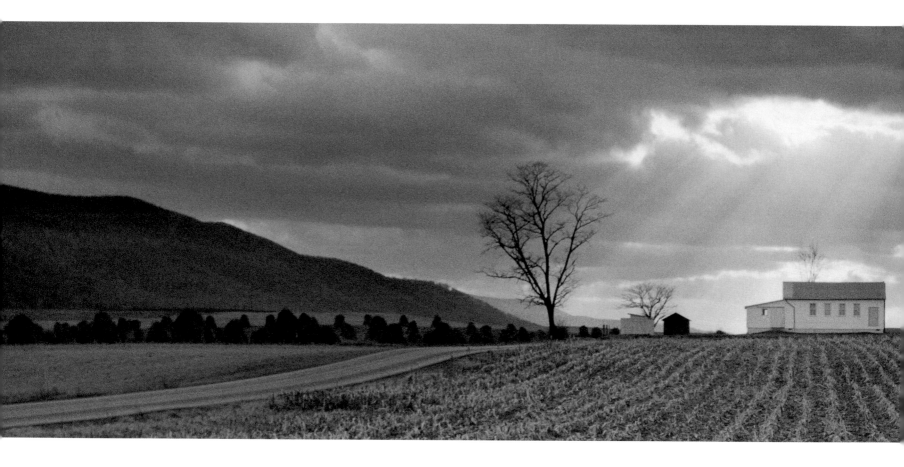

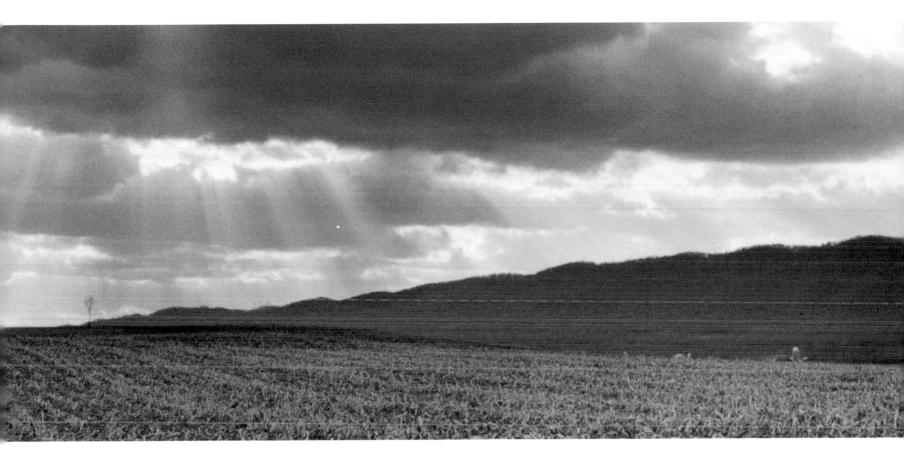

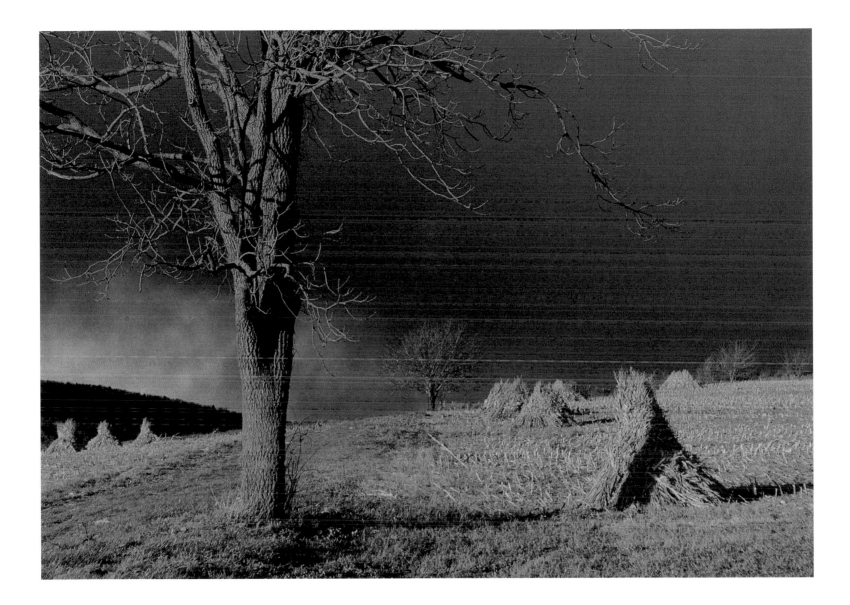

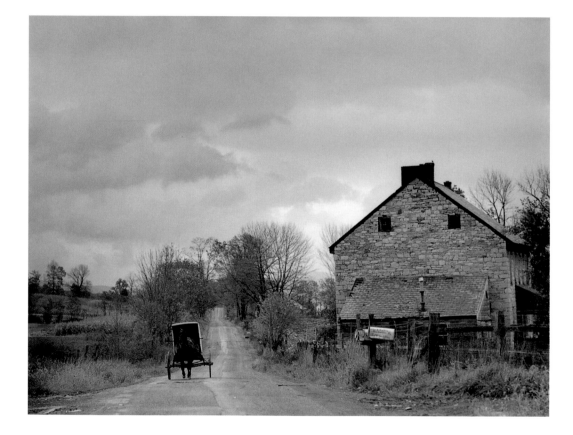

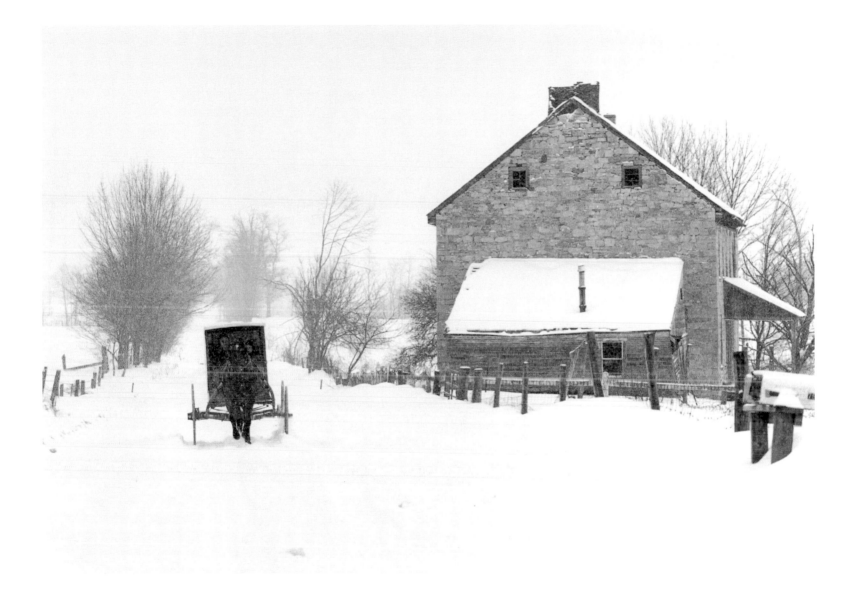

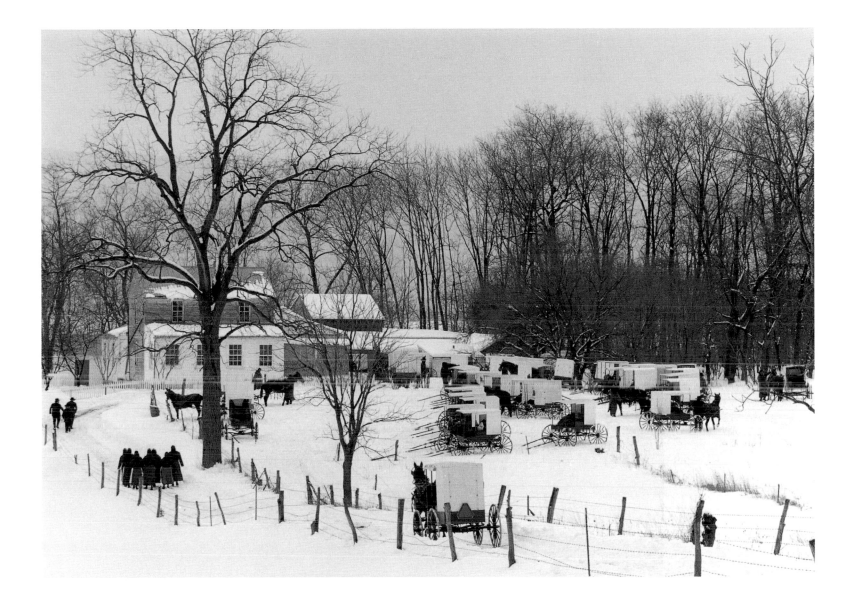

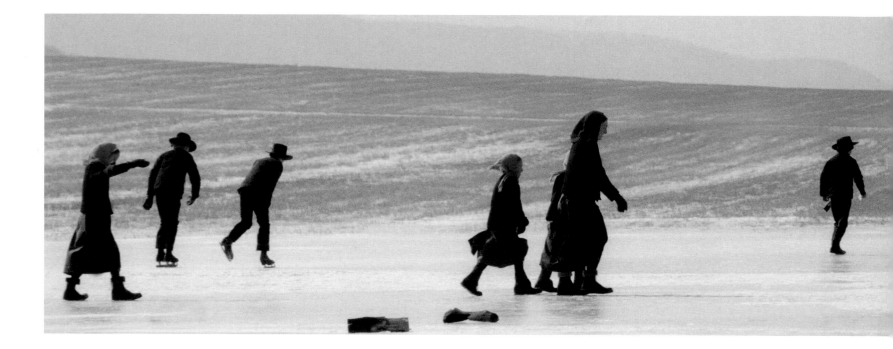

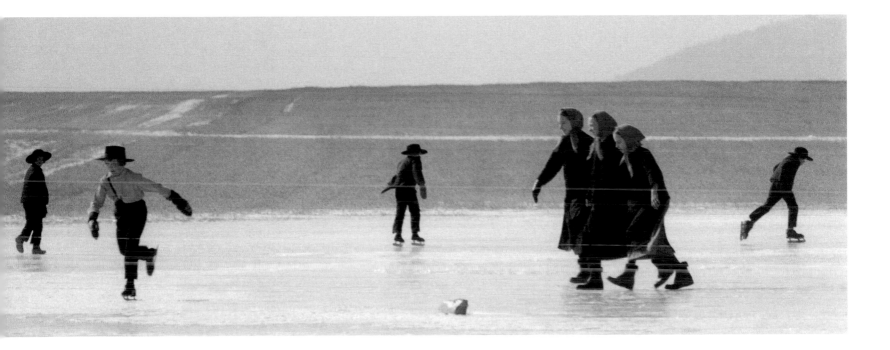

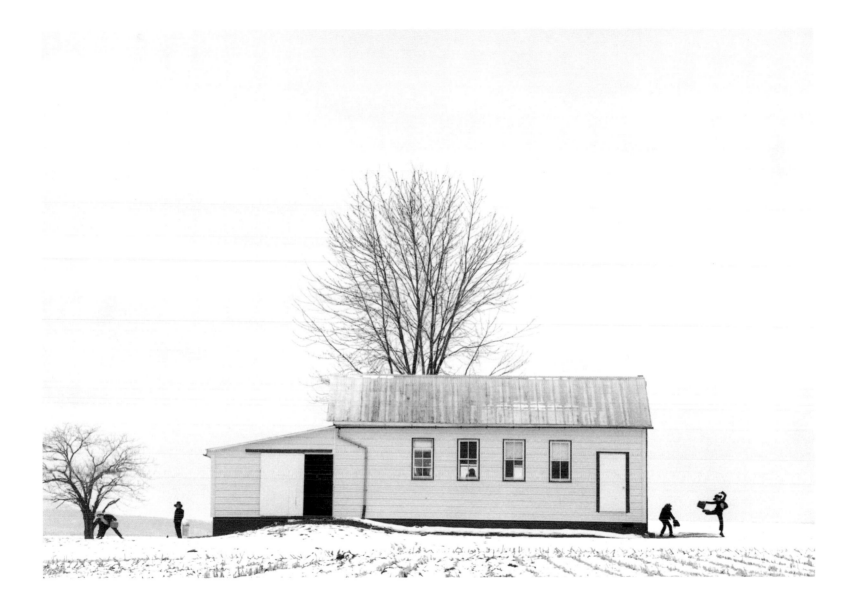

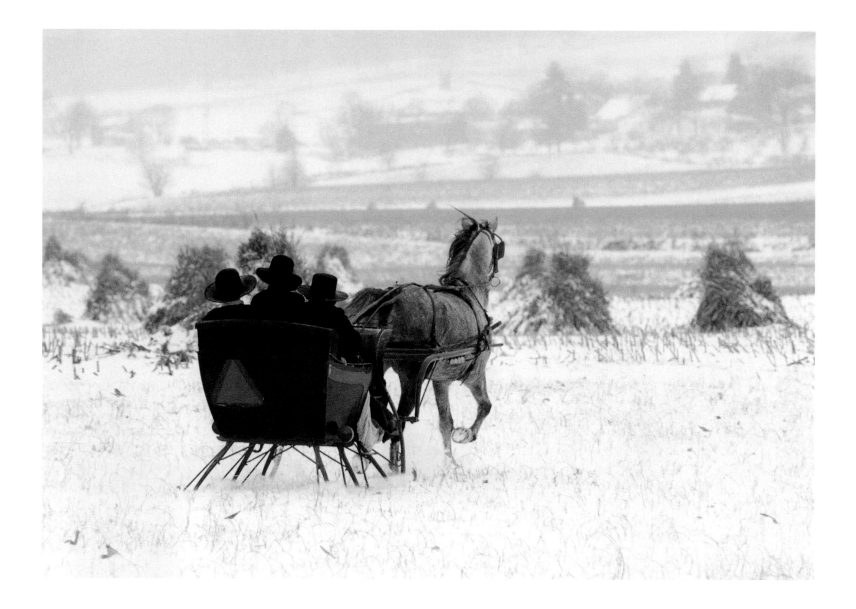

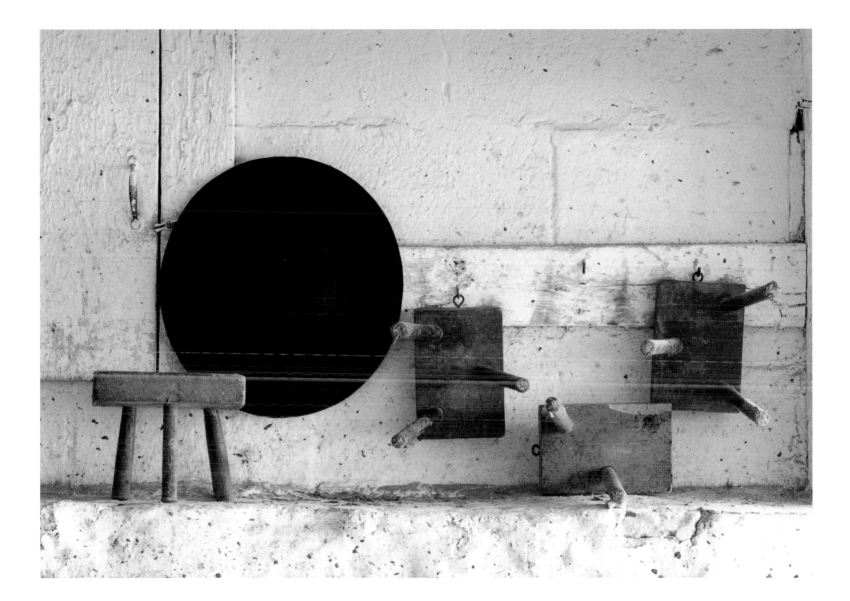

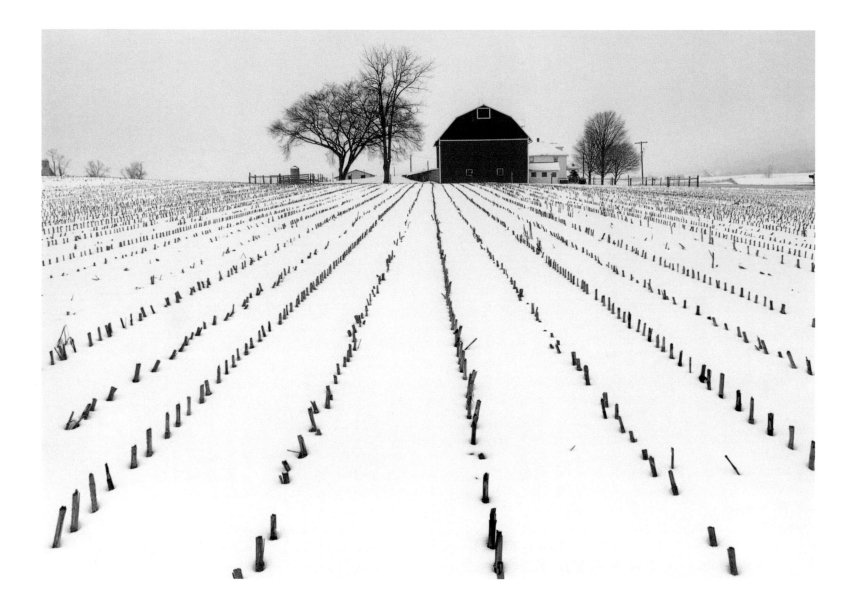

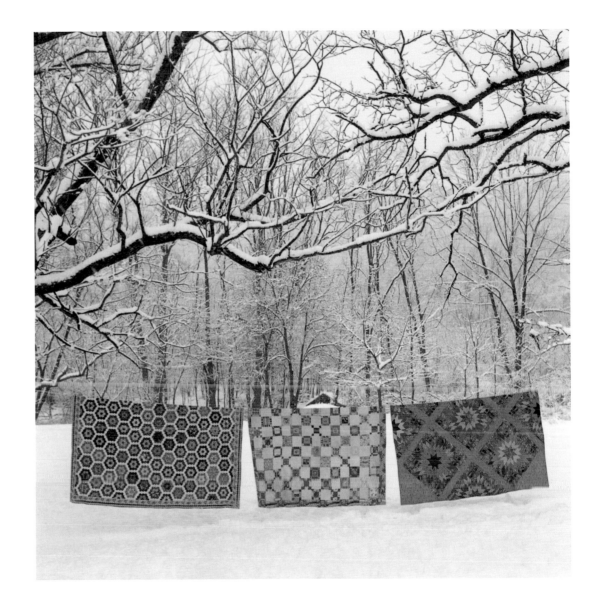

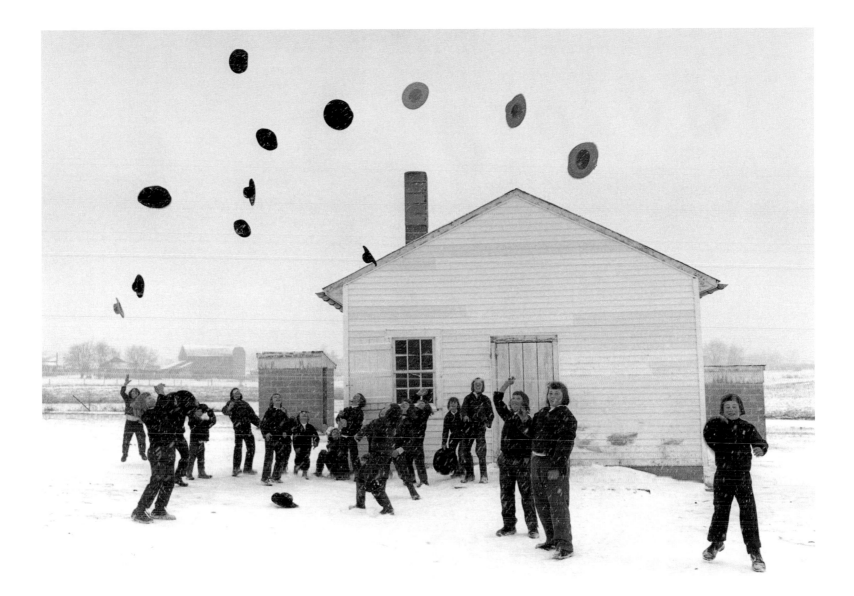

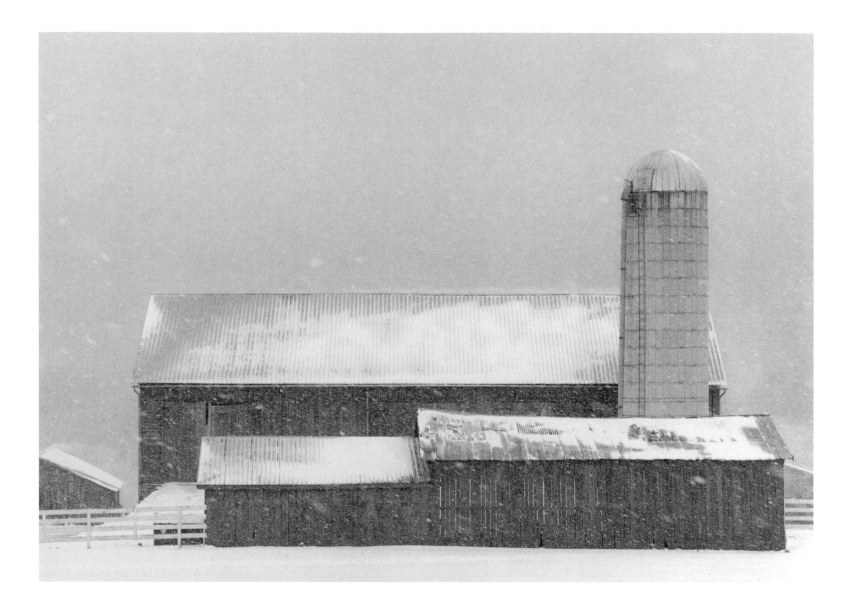

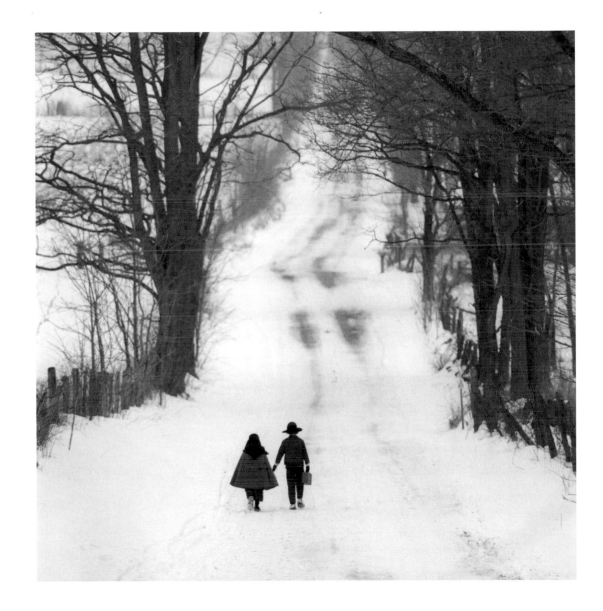

PHOTOGRAPH TITLES

Photographs not listed here are untitled.